SPONTANEOUS URBAN PLANTS

Weeds in NYC

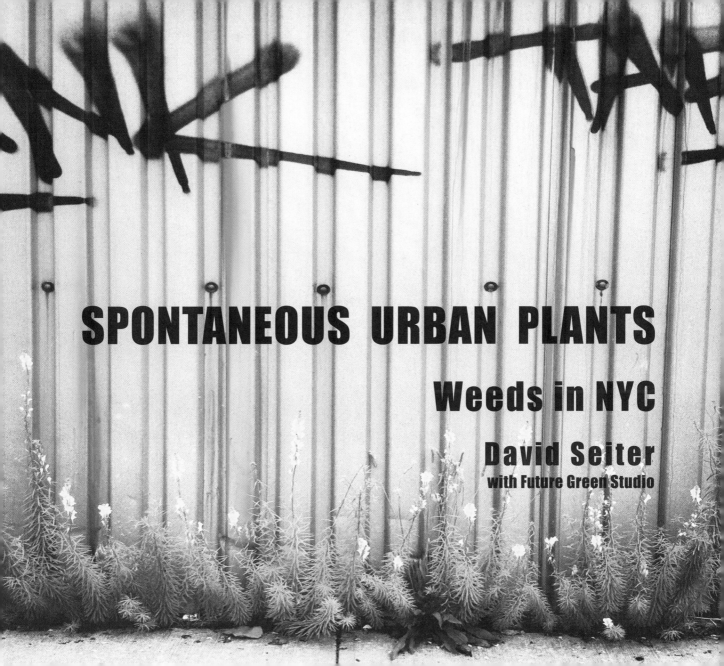

SPONTANEOUS URBAN PLANTS

Weeds in NYC

David Seiter
with Future Green Studio

ARCHER | RARE BIRD
601 West 26th Street, Suite 325, New York, NY 10001
453 South Spring Street, Suite 302, Los Angeles, CA 90013

FIRST HARDCOVER EDITION

Printed in Canada

Publisher's Cataloging-in-Publication data available upon request

Seiter, David
Spontaneous urban plants : weeds in nyc/ David Seiter.
p. cm.
ISBN 9781941729076
Includes index.
1. LCSH Weeds. 2. Urban plants—United States. 3. Urban planning—New York. 4. Waste lands—New York (State).
5. Urban ecology (Biology). 6. Land use, Urban—United States.
LCC QK83 .S45 2016
DDC 581.6/3—dc23

CONTENTS

To Lo + A
The future exists first in imagination
then in will, then in reality
Don't wait to see what others do
be the change you wish to see in the world

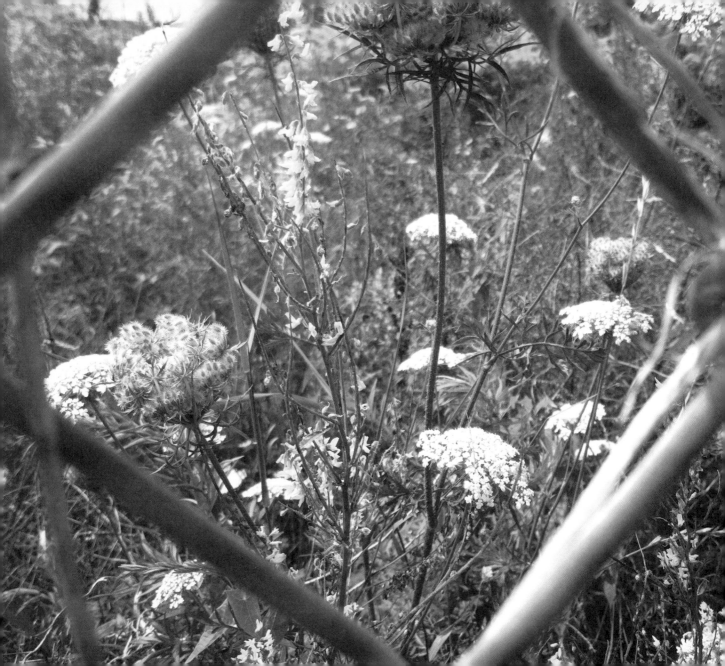

FOREWORD

BY TIMON MCPHEARSON

In an era of rapid urbanization, climate change, biodiversity loss, and environmental degradation, it is critical that we find innovative ways to reinvent our connections to nature. As urban population growth explodes, the future connection of all humanity to the natural world will heavily depend on how humans relate to nature within cities. Human dependence on nature is a fact. Our future relies on the quality and quantity of the nature we have in cities, and on the opportunities for everyday citizens to benefit from it, care for it, and become more closely connected to it.

There is increasing awareness that urban ecosystems are a critical component of our human health and well-being. Hundreds of articles in medical journals are steadily documenting the incredible power of nature to improve recovery following surgery, decrease stress during the workday, increase attention and productivity, modulate our emotions, provide solace, and serve as places for social bonding and connection that is critical to improving personal and community resilience. But urban nature has the power to do much more.

Ecosystems in cities are key elements in helping municipalities adapt to the effects of climate change. New York, as well as cities all over the world, is increasingly turning to nature as a cost-effective solution to deal with threats from rising sea levels and coastal flooding, to offset more prolonged heat waves, and to mitigate effects of increased storm frequency and intensity. Urban flora offers a wide range of these benefits: helping to absorb excess rainwater and prevent flooding, providing cooling in hot weather, absorbing carbon, producing food, soaking up air pollution, decreasing noise pollution, providing opportunities for recreation, and helping to generate a sense of place. To decrease our vulnerability to climate change in cities, we have to become stewards and manage this nature to maintain its functions and services.

Urban plants have to deal with drought conditions, extreme heat, pollution, human disturbance, and competition from invasive species. Despite this difficult environment, our urban ecosystems are amazingly diverse, beautiful, and functional. New York City actually harbors 40 percent of all the rare and endangered plant species in New York State and 85 percent of the state's bird, mammal, reptile, and amphibian species. The city is literally teeming with life and serves regionally as a hotspot for biodiversity. More than 360 plant species, 270 birds, 260 fungi, 290 invertebrates, and 18 mammals have been observed in Central Park alone. At the same time, not all species can survive and flourish in our current urban conditions. One of our challenges is to imagine, then design and build, a future city that can accommodate

a richer, more abundant nature, improving the ability of ecosystems to function for other species, and providing the ecosystem services needed for a growing urban population.

With global biodiversity under severe threat from urbanization and other development pressure, the expansion of cities into some of the most sensitive biodiversity areas on the planet has the potential to further devastate the global genetic, species, and ecosystem richness we evolved with. But this is not a foregone conclusion. Cities could instead take up the challenge to develop differently. Why not bring nature into every development enterprise we have? With literally trillions of dollars earmarked for urban development, especially in the Global South, developers, architects, engineers, and designers have an incredible opportunity to shift the development trajectory towards more sustainable and ecologically inclusive infrastructure. Making room for nature can not only help us combat global biodiversity decline, but can also make our cities more livable, more resilient, and more sustainable, perhaps even averting the sixth great planetary extinction.

The critical innovations of this book and the work of Future Green Studio are in helping us find ways to work with our existing urban nature in order to utilize the plants and other species that have already adapted to the harsh realities of cities. Their designer science will provoke more discussion around spontaneous urban plants. Which species work best for which project? How should we deal with invasive species, precisely

because they may also provide some of the functional, aesthetic, and sociocultural benefits we hope for? When will we start to understand that ecology is the foundation upon which to design our urban future?

This book is an important piece of the larger puzzle for how to incorporate urban nature into our daily lives, our built infrastructure, and our planning and design efforts for a better city. Weeds have, by their very name, a negative connotation. It's time we took a step back and re-asked the question—what are the ecological benefits of weeds? Many of our weedy species are extremely hardy and well adapted to city life. This is a functional attribute more designers, landscape architects, and ecologists should learn to embrace. Spontaneous urban plants are not silver bullets to solve climate change, social inequity, or public health challenges. However, they are a critical element along with the many other aspects of urban nature that we must harness to shift the trajectory of the near-term urban development projects along more desirable pathways. The full complex ecological milieu present in even the smallest of urban spaces, including plants, microbes, insects, birds, and mammals, has the potential to help us become more connected to nature, more resilient to climate upheaval, and simply make our cities more beautiful.

Timon McPhearson is Assistant Professor of Urban Ecology, Chair of the Environmental Studies program, and Director of the Urban Ecology Lab at The New School in New York City, where he studies the ecology in, of, and for cities and teaches ecology, resilience, and systems thinking.

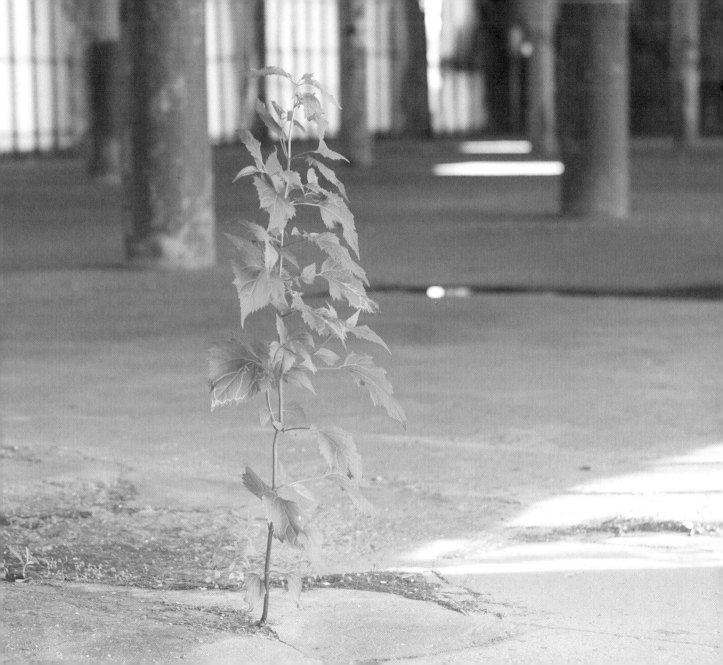

INTRODUCTION

BY DAVID SEITER

As I see it, the critical question faced by the professionals who design, build, and maintain our urban landscapes is not what plants grew there in the past, but which ones will grow there in the future?... The real ecology of the city is all about the dominance of invasive species, while the cultivation of the native species that once grew there seems as artificial as a French-knot garden. [i]

—Peter Del Tredici

#spontaneousurbanplants

#spontaneousurbanplants was an Instagram-powered art and research project which explored the overlooked ecological services that weeds offer in our urban environments. Conducted by the Brooklyn-based landscape design firm Future Green Studio, the project was multifaceted in its scope. Part performance piece, part photo documentation project, and part ecological investigation, the project attempted to use conceptual ideas of wandering, photo filtering, and plant indexing as tools to reframe our preconceived notions about weeds in urban areas. Leveraging principles of urban ecology and environmental aesthetics, the research project stimulates discourse between the different trades whose work touches on ideas of our new urban future—ecologists, architects, urban planners, engineers, policy makers, artists, and the general public.

We generated the project through a series of loosely organized walks through the city to survey spontaneous urban plants that included photo documentation of the weeds in their habitats and extensive research into the characteristics and cultural histories of the plant species found. Those individual efforts were synthesized into a website that serves as an interactive database of weeds. The website, *spontaneousurbanplants.org,* is a user-generated database of weeds in the urban environment that maps photographs of plants by utilizing the social media application Instagram. Ubiquitous and immediate to the urban wanderer, Instagram is an interesting tool for reconsidering the aesthetics of weeds and bringing findings to the wider public. The use of Instagram filters helps to sensationalize the photos and spark greater interaction with an audience beyond the professional realm of urban ecology. Our intention is to use photography as a tool to reframe societal perceptions of weeds and challenge the common assumption that they lack aesthetic value.

As a collaborative design studio of horticulturists, landscape architects, and artists, we designed the project to engage the public and promote collaboration. A user walking through the city with their smartphone may spot an interesting urban weed emerging from the sidewalk, snap a photo, and post it to their Instagram

feed with the hashtag *#spontantaneousurbanplants*. Followers of the user can view the image, comment on it, or follow the hashtag link for more spontaneous urban plant images. Each photo that is taken and hashtagged *#spontaneousurbanplants* enters the website interface for validation and identification. A horticultural team identifies the plant species as best as possible based on the visual characteristics apparent in the photograph and a timestamp is extracted from the metadata of each photo. This helps to distinguish the seasonality of documented species and the ephemeral qualities that the weed exhibits throughout the day. As the inventory of plant species builds, multiple images of each species document the seasonal shifts and visualize the blooming and seeding sequences of the plants through photography.

Once identified, each plant image is mapped to its original photographed location. As each photo is added to the database, a vast field of images taken from around the city emerges showing a gradient of different densities. Particular areas with a lot of photographs indicate the places where social interaction and rampant weed growth overlap. Through the aggregation of images, a patchwork ecology emerges that is resilient, self-functioning, and unmanaged.

This emergent system of plants that thrive in areas few other plants can grow offers substantial ecological services to the urban environment. On the website, plant images are filtered through a weed value-matrix that catalogs both the positive and negative ecological

services provided by each species. While many of the spontaneous urban plants included in the survey offer multiple ecological services, future research into the topic needs to apply quantifiable metrics to the performance characteristics of each plant.

Through a subjective process that includes walking, photography, and mapping, *#spontaneousurbanplants* research stems from a broad accumulation of information to analyze and extract patterns, behaviors, and seasonal shifts from the data that is generated. This online educational resource is intended to offer insight into the characteristics, habitats, and benefits of spontaneous vegetation in urban areas. In addition, it disseminates the user-generated findings through accessible graphics, opening up the discourse about the value of weeds to those outside of the professional landscape world. More based in art than rigorous science, the project's intention is to catalyze more research into spontaneous urban plants and facilitate an intelligent public dialogue around the perception of weeds. We hope the discussion generated brings more funding opportunities for investigative studies so that urban ecologists and environmental engineers can comment from a place of rigorous scientific research and proven metrics.

This project was not created by scientists or ecologists, but from designers who inhabit these rogue landscapes every day. As such, more questions have emerged than answers: How can we create an objective framework for the analysis of weeds from our own subjective analysis? What does our user-

generated data say? What are the types of weeds being found? Where are the habitats that they thrive in? What substantial ecological services are they providing to us? How are they surviving in these extreme and hostile conditions? What principles of the plant's physiology or performance can we extract and replicate in planning for a more resilient urban future? Are the successful weeds today indications of resilient species types that will thrive twenty years from now? Can an efficiently designed and managed system of spontaneous plants be a low-cost strategy for cities trying to adapt to climate change?

Through an emphasis on urban wandering and themes of psychogeography—which, in their essence, inspire a reimagining of cities' physical and imaginative spaces—our research project uses the lens of spontaneous urban plants to codify that sense of exploration, and in the process, hopes to subvert conventional perceptions of cartography and its role in defining our urban spaces. Our goal is to question the hegemonic interpretations of weeds and the top-down approach to mapping urban space while at the same time instigating a more robust discussion on the role of spontaneous urban plants in our climate-adapted future.

An Overlooked Sustainable Ecology

Weeds are everywhere, magically emerging as alien invaders. Stigmatized as undesirable, these seemingly ubiquitous plants are part of our collective human experience. Although we tend to think of our cities as concrete jungles, our post–new urban environment is awash in plant life. This becomes especially apparent when you begin recognizing the wild urban plants that have taken root along roadsides and chain-link fences, between cracks of pavement, within vacant lots, rubble dumps, and highway medians. These resilient plants find distinctive niches to thrive in and inhabit our most derelict landscapes. The environmental benefits of these "weeds" go widely unrecognized when, in fact, this urban ecology can offer a fresh perspective on how contemporary cities perform. In the stressful landscapes of contemporary cities, wild urban plants can provide real ecological benefits, and are the overlooked backbone of an emergent green infrastructure.

In colloquial terms, these plants are most commonly referred to as "weeds," but are also known as "invasive," "alien," and "exotic." Culturally, the prevailing usage of "weeds" relegates these urban plants to an inferior botanical category because humans did not intentionally cultivate them at the particular site in which they have appeared. It is an understandable human reaction, as we have been taught, generally, that things which require little to no effort to grow, create, or maintain have less value. But competing perceptions of certain plants reflect the need to think differently about the stigma we attach to these weeds; for example, dandelions are perceived by suburban homeowners as an unrelenting lawn invader, yet by children, they are seen as a thing to play with, and by urban foragers they're recognized as food. In my own garden, fig buttercup (*Ranunculus ficaria*) and white snakeroot (*Ageratina altissima*) have

drifted in and been allowed to establish, each in their own ephemeral way. My kids are especially open— not yet having adopted the societal value judgment of whether a plant is acceptable or not. Their innocence and fresh perspectives are qualities I try to adopt when viewing spontaneous urban plants in the city.

The term "invasive" denotes a nonnative plant that causes harm to environment, economy, or human health. Determined in New York State by the Department of Environmental Conservation, the invasive species regulations help to control the introduction and spread of invasive species by limiting commerce in those species.[ii] Denounced for taking over natural areas and stifling biodiversity, invasive plants like common reed (*Phragmites australis*) can have a destructive impact on our native ecologies and establish rampant monocultures which force out all other plant communities. With many invasive plants dispersing seeds multiple times throughout a season, and with seed counts in the thousands per plant annually, the potential for them to rapidly colonize rural and suburban sites is a major concern.

On the other hand, in strictly urban areas, some of these plants deserve careful consideration. For example, *Phragmites* has one of the highest biofiltration rates of any plant, cleansing the water and extracting heavy metals and toxins from the surrounding soil. Another invasive plant known for its rampant growth along roadsides is Japanese knotweed (*Polygonum cuspidatum*)—which also offers positive benefits in urban areas by colonizing disturbed soils and helping

to prevent soil erosion. Additionally, one of the most ubiquitous urban weeds is the tree of heaven (*Ailanthus altissima*). Found on seemingly every block in New York City, this invasive plant it is not counted in the city tree census and is no longer acceptable to be included among the intentionally-planted trees for a campaign like New York City's *Million Trees Campaign*. Yet the tree of heaven is a quick growing woody tree with substantial carbon capturing characteristics and the leaf index mass to contribute significantly to mitigating the urban heat island effect. Most importantly, it should be noted that in most cases the terms "invasive" and "weed" are not interchangeable. Not all wild urban plants are invasive, and in fact, roughly 35 to 40 percent of the Northeast urban flora included in recent studies are native to North America.[iii]

Our contemporary urban streetscapes and post-industrial vacant lots do not mimic the Northeast deciduous forests of our past—once suitable growing grounds for native plants. Scientists would be the first to agree that nothing is pristine. All landscapes have been altered by human activity. Rather than just trying to control our new urban ecology with heavy doses of herbicides, we should instead evaluate each specific site independently. Ecological restoration in urban areas has its challenges and the value that the finished product offers to the local environment should be evaluated against the benefits that its existing landscape offers. In addition, the economic expenditures and embedded energy needed to complete the restoration project should be strongly considered. Simply put, without extensive maintenance of intentionally native planted

landscapes, most urban sites would quickly revert to being dominated by spontaneous vegetation. One major concern is that our current maintenance program for weeds in New York City parks includes pervasive use of the Monsanto-produced herbicide, Round-Up.[iv] This chemical's primary active agent, glyphosate, was labeled as a probable carcinogen by the United Nation's World Health Organization and has been banned by multiple developed countries across the globe. [v]

The ability for spontaneous urban plants to adapt to the disturbed conditions we have created is what makes them so attractive when thinking about climate change and the future of our urban environments. According to the Earth System Research Laboratory at the National Oceanic and Atmospheric Administration, the global monthly average for carbon dioxide concentration in March 2015 surpassed 400 parts per million, which was roughly 25 percent higher than levels in 1960, and the trend was suggestive of a continued exponential rise.[vi] What many people fail to acknowledge is that the amount of carbon dioxide in our environment is so high and pervasive that virtually all of nature is now disturbed. Higher levels of carbon dioxide create different growing conditions, as the plants typically require more water, have less nutritional content, have lower rates of photosynthesis, and have difficulty absorbing nitrogen. There are also indications that plant chemistry can be affected, making plants more susceptible to insect infestation and disease.[vii] In plain terms, as carbon dioxide levels rise temperatures will be elevated, increasing the global land area of deserts and causing other ecosystems like tropical forests or grasslands to migrate to the poles. It's safe to assume that a plant species that was native to the northeast United States fifty years ago may no longer thrive in the same location in the future.

Weeds are a renegade green infrastructure, thriving in places most native plants won't grow and providing substantial benefits to urban dwellers. The ecological and human benefits that wild urban plants offer are wide-ranging—these plants capture carbon, are edible, have medicinal properties, create wildlife habitat, retain stormwater, and phytoremediate disturbed soils. In addition, spontaneous urban plants are disturbance adapted, contribute to lowering the impacts of the urban heat island effect, and colonize bare ground which stabilizes soil and prevents erosion. When creating an index based on the services each plant offers, it is important to acknowledge aspects of particular weeds that have destructive impacts on ecosystems and humans. We included the following positive and negative services as chapters in the book:

Carbon Sequestration—Quick-growing woody trees with high leaf mass indexes that thrive in tough conditions like princess tree (*Paulownia tomentosa*) are very effective at capturing carbon in urban areas.

Edible—The rise of urban foraging has begun to situate weeds in our contemporary edible lexicon. Both dandelion (*Taraxacum officinale*) and common purslane (*Portulaca oleracea*) have delicious leaves and are highly sought after, finding their way into salads at trendy restaurants.

Medicinal—A wild urban plant's ability to be used for medicine is a positive service the plant can offer humans. Plants like evening primrose (*Oenethera biennis*) and mugwort (*Artemisia vulgaris*) are frequently used in alternative medicine for their range of healing qualities.

Wildlife Habitat—Offering a food source and, at times, shelter, wild urban plants provide an important value to small mammals, birds, insects, and bees. Plants like common milkweed (*Asclepias syriaca*) are an essential link in the life development of the monarch butterfly.

Stormwater Retention—Many urban storm sewer systems are completely overwhelmed, with raw sewage frequently being released into our urban waterways. Prostrate weeds that grow between sidewalk cracks like goose grass (*Eleusine indica*) play an important role in slowing down the first flush of stormwater and reducing the cumulative impact of major storm events.

Phytoremediation—Some plants like lambsquarters (*Chenopodium album*) have the capacity to absorb pollutants, toxins, and heavy metals from degraded soils. These remediation properties are being explored for their viability to strategically cleanse brownfield sites.

Ecological Disservice—The best example of a human or ecological disservice is the pervasiveness of ragweed (*Ambrosia artemisiifolia*). Ragweed is a plant whose fall flowers release tiny grains of pollen which cause an allergic reaction in many people and contribute to an increase in the number of cases of hay fever.

With vast paved surfaces absorbing heat, high levels of pollution in the air, and degraded soils from road salts and heavy compaction, our cities reflect the substantial impact human disturbance can have on natural ecologies. The landscape of our cities is the best analogy we have to model and plan for the climatically-affected landscapes of the future. Urban plants require little to no human assistance to assert and maintain themselves in extreme, often volatile urban conditions, while providing many of the same ecologically performative benefits of native plants. This pervasive vegetative system, through its smallness and persistence, has the potential for a greater inherent stability and resiliency in the face of the unexpected forces of climate change.

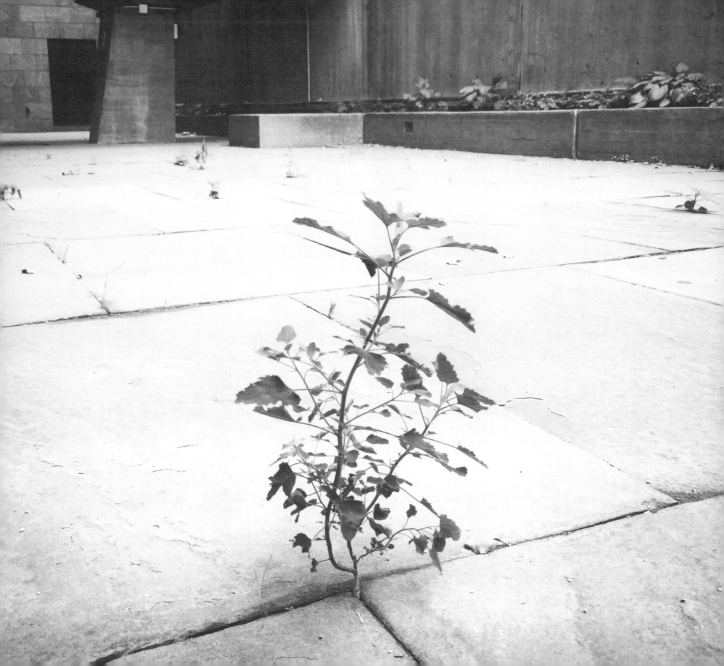

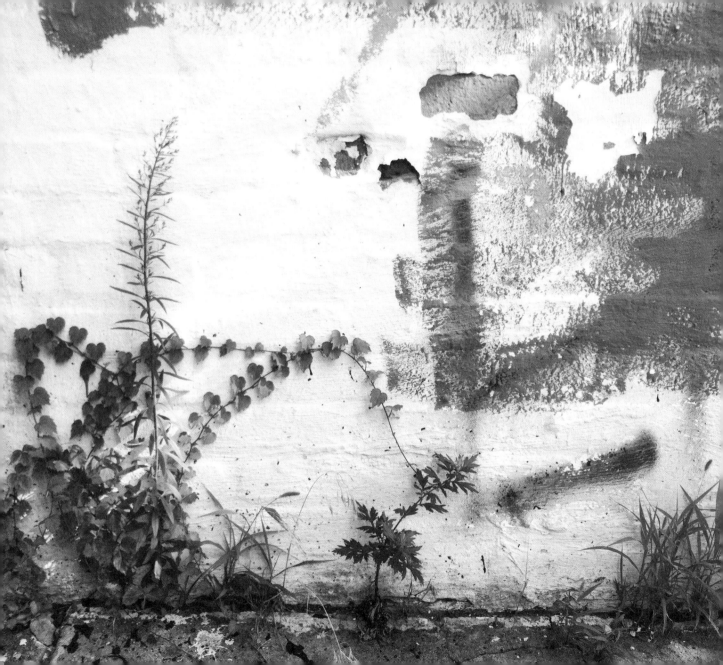

EXPLORING ROGUE TERRITORIES

BY DAVID SEITER

The task is...not so much to see what no one has yet seen; but to think what nobody has yet thought, about that which everybody sees. [i]

—Arthur Schopenhauer

Whenever traveling to a new city, I always want to understand its layout, its sequence of spaces, its edges and boundaries and the relationships between urban landscapes and landmarks. While reading a map helps to provide one kind of perspective on the city, there is nothing like just getting lost and wandering as a way to orient yourself to your surroundings. The rhythm of your steps and the open-ended nature of your route allows your mind to drift, helping you to slip into a meditative state that opens your acceptance of the unexpected and the overlooked. Streets, sidewalks, and signs don't direct your movement through urban space but rather your path is determined by your intuitive sensibility. Drawing on social, spatial and eidetic cues, the wanderer follows their instinctual motivations to inhabit space, reading the psychogeographical terrain of the city to reveal its poetic nature. This way of moving through the city breaks down the hegemony of planned urban sequences and suggests a deeper reading of the city that is from the ground up and emergent. In this spirit, wandering is understood as an investigative practice and a method towards a new way of seeing.

In today's digitally navigable world, where nearly everyone has a smartphone with mapping apps a touch away, it is more important than ever to walk off the beaten track and explore the remnant urban fragments that are not digitally mapped on navigational devices. Wandering the demapped zones of abandoned parks, waterfront dead-ends, infrastructural edges, or vacant lots is an opportunity for urban dwellers to actively traverse and reconsider their surroundings as a shifting landscape that can be reshaped by their own perceptions. Architect and professor Francesco Careri, in his book *Walkscapes*, writes, "...walking is an aesthetic tool capable of describing and modifying those metropolitan spaces that often have a nature still demanding comprehension, to be *filled with meanings* rather than designed and *filled with things*." [ii] The underutilized spaces of our cities often contain a persistent wild nature that warrants attention and holds significance. These void spaces are essentially a landscape or a sort of connective tissue that exists only where the structure doesn't. Walking through these "spaces in between" may help us to reveal the latent potentials that each plant or site holds—motivating us to fill our urban voids with meaning instead of things.

The City is the site—the focus of our wandering investigation. New York City functions somewhat like a vast ecosystem that is constituted by its diverse sets

of people, its remnant, patchwork ecology, and its aging infrastructure of roads, buildings, and systems. In New York City, sometimes it's easy to get caught up in the hustle-bustle and forget about the "nature" part of that equation. At the end of my first month of working in the city, I was walking down Varick Street just south of Houston and passed by construction workers that were tearing up the sidewalk. The rich, reddish-brown, fecund earth was spilling out of the hole and smearing onto the sidewalk. I reached down and grabbed a handful. I simply could not believe that the earth actually existed under the pavement. I hadn't seen real dirt in so long that I truly forgot that it was subversively lurking under all that concrete. Nature still existed—I had just overlooked it. At the time, it made me think of art historical references like Marcel Duchamp's readymades or Robert Smithson's Theory of Non:Sites where the found object is removed from its original location and through its repositioning, a deeper, more significant meaning is revealed.

When analyzing our urban ecology with a critical eye towards repositioning its mundane and found conditions, the most dominant, self-replicating natural system operating in our disturbed landscapes is the loose network of spontaneous vegetation. In the urban realm, these volunteers are often unwanted and every attempt is made to eradicate them. Instead of dismissing them, we should be trying to understand why spontaneous urban plants are so successful in our tough urban conditions. These conclusions might provide the biggest insight for designers to strategically rely on the ecological services of spontaneous urban plants in the face of climate change.

Climate change is causing more unpredictable weather patterns, longer periods of drought, and increased fluctuations in temperature, which is causing cities to reevaluate their resiliency. In thirty years, the climate of the northeastern United States is going to be much different than it is today. In order to adapt to the realities of climate change in our future, we need to plan to have resilient urban flora that is both ecologically productive and aesthetically pleasing. Landscape architects, policy makers, and municipalities need to better understand the technical complexity and economic output required to realize those visions. We need to promote vegetation within our cities that will allow us to use less water for irrigation, subsist with relatively little maintenance, and be self-replicating in a way that requires very little oversight. Every possible surface in the city—the walls, the streets, the roofs, the edges, the remnant vestiges, and the vacant territories—are areas to colonize and opportunities to be utilized. As we plan for more livable resilient cities, how can we do so with an eye towards sustainability, management, and fiscal responsibility? How can we incorporate more green spaces into our urban environments while minimizing our installation, maintenance, and operational costs for these green spaces?

A Series of Horizontal Natures

Throughout time, our perception of the natural world around us has undergone incremental shifts which have left a deep imprint on our consciousness. One such perspectival shift occured when we rose out of the primordial meadow, perceiving the expansive

landscape and our vulnerability within the more complex otherworldly system. We experienced a shifting of perspectives where all of a sudden we realized how embedded within the landscape we were previously, and yet how disconnected and unaware we were of our place' in the greater world. As we began to understand that we are exposed, we sought out protection and shelter—inhabiting caves and other natural yet strategically ensconced areas. Coincidental with themes of protection, our earliest intentional interventions into the earth included inhabiting landscape as shelter and carving out rustic, square pits in the ground to accumulate water so as to serve as irrigation for adjacent crops. In addition to themes of nesting and collecting, our development of simple tools allowed us to clear forests, cultivate crops, and domesticate animals. In this Neolithic era, shelters, earthen mounds, and monuments were constructed—demonstrating man's presence within the hostile world.[iii] At this time, a dialectic emerged where man began to see himself in opposition to the larger nature of which he had previously been a part.

Landscape architecture as a discipline and profession continually explores the historical relationship between artifice and nature, or the constructed object and the vast landscape. Landscape architectural historian John Dixon Hunt, in his book *Greater Perfections*, writes of "a series of differentiated natures," often horizontally juxtaposed in space, that have been used to understand our relationship to nature.[iv] The idea of *three natures* was originally introduced in the Renaissance and represents the unfolding layers of

space between the artificial and wild—each layer incorporating a different level of human intervention.

First nature came to represent the wilderness—unreachable and sacred. Represented in landscape paintings far off in the distance, *first nature* is an inaccessible landscape, like the mountaintop or the moon. First nature is best represented by places that were revered for their absence of humans and therefore held the projections of people's hopes and dreams. It was an unknown nature where the mysterious and the sacred became intertwined.

Second nature was the cultivated landscape of known lands, paths, and small-scale agricultural fields. It was the nature historically beyond the walls of the site used for agricultural or other productive landscape purposes. In hunter-gather societies, this was perhaps the known territory of walked paths along which berries and nuts were picked.

Third nature was the manicured gardens surrounding an architectural intervention—an art form blending landscape and culture. Within the walled enclosure, this tended and tidy nature was found in the formal gardens of estates and castles. Highly visible, these gardens became an extension of architectural program, offering places for rest and leisure while at the same time being articulated forms of cultural expression.

Our contemporary perceptions of nature are more complex given the amount of disturbance humans have caused. With unchecked disastrous weather

and freak storms on the rise as a result of human impact and climate change, the boundlessness and wildness of nature can connote a sense of danger. At the same time, the sense of an untamed, unknown *first nature* is a fading vision as we've evolved as a species and claimed more and more territory as our own. Everything has been traversed, collected, understood, and known. The best example of the elimination of *first nature* from our consciousness was demonstrated in 1969, when we walked on the moon, planted an American flag, and called it ours. Prior to this, the moon had retained its sacred value as an otherworldly object that everyone could see but no one could touch, let alone claim as territory.

The truth is, nature is fragile and precious. It is in need of protection from our industrial footprint and deserves our stewardship and advocacy. In his encyclical on climate change, Pope Francis writes, "A sober look at our world shows that the degree of human intervention, often in the service of business interests and consumerism, is actually making our earth less rich and beautiful, ever more limited and grey, even as technological advances and consumer goods continue to abound limitlessly. We seem to think we can substitute an irreplaceable and irretrievable beauty with something which we have created ourselves."[v] At the heart of this issue is the understanding that personal autonomy has been co-opted by consumerism and that nature is currently in the service of big business. Some urban theorists have even suggested a *fourth nature* as an additional classification to include the post-industrial landscape that has been altered and significantly degraded by our presence.[vi] Scientists have suggested that we are in a new geologic era called the *Anthropocene* due to human's profound influence on the state, dynamics, and future of the Earth system.[vii]

A Taxonomy of Urban Landscapes

Globally, we have passed a population tipping point, where for the first time in the history, more people live in urban centers than in agrarian conditions. In 2014, 54 percent of the world's population lived in urban areas, but by 2050, that number is expected to increase to 66 percent.[viii] While dense urban environments are on the rise worldwide, in America people want to live in more spread out cities. Architectural historian Witold Rybczynski writes, "all the (American) cities that have experienced vigorous population growth during the second half of the 20th century—Houston, Phoenix, Dallas, San Jose, Atlanta—have grown by spreading out. These are horizontal cities, with generally low population densities."[ix] At the same time, many of our older post-industrial cities are experiencing a rapid population decline. In these cities, like Detroit, a void urbanism has taken over that is based on erasure and de-development.

Three contemporary urban typologies—the *hyper-dense city,* the *void city,* and the *horizontal city*—are particularly appropriate to explore how nature is integrated into the urban fabric. The typical *hyper-dense city* is an overpopulated, vertical city that is seemingly devoid of vegetation. Here landscape has

been pushed out by the sheer volume of people living in a given area. Shanghai is one such city, with satellite images showing little to no tree cover. According to the world culture report, Shanghai is one of the least green cities in the world with just 2.6 percent of its total land area devoted to publically accessible green space.[x] If planned correctly, the small footprint of dense urbanism can conserve resources and be energy efficient by requiring less transportation and utility infrastructure. It can be argued that if we left nature wild, uninhabited, and relatively undisturbed by focusing development in vertical cities, our ecology might have a greater chance of restoring its own balance.

At the other extreme, the *void city* has a post-industrial past and is characterized by its abandoned structures and rampant overgrowth of spontaneous vegetation. In many cases, the city had been successful; grown to its height and breadth, and then collapsed, like a vacuum sucking the air out and left behind is a patchwork of vacant lots. Comparing maps of Detroit from 1950 to 2000, vast territories of the city have literally been dissolved. Planned to be machine-like with strict organizational principles, the development of Detroit coincided with the invention of the assembly line. When the principles of mass production were applied beyond the industrial complex to the city as a whole, the traditional, closed urban form began to break down. Urbanist Grahame Shane writes, "the effects of Fordism and the 'city machine' model of organization dissolved the industrial city itself into the landscape."[xi] Today, Detroit is overcome by an uncontrolled nature where plants grow spontaneously around, inside, and

on top of buildings—actually ripping down structures and reducing them to remnants. Now filled with more voids than structures, fewer machines and more wilderness, there is no longer a dialectic of inner city versus outer nature, but rather a wonderful and messy, intertwined place where wild vegetation has fully meshed with the built environment. Learning from Detroit, urbanist Charles Waldheim coined the term Landscape Urbanism to capture landscape's potential to supplant architecture as the primary driver of urban form—especially in the leftover void spaces of our decentalized cities.

New York City has elements of both the *hyper-dense* city and *void city* typologies. It can be argued that the city has absorbed dense urban developments along the High Line Park and in Hudson Yards without significantly altering its urban fabric.[xii] At the same time, New York City has a vast patchwork of vacant lots, waterfront edges, and open post-industrial sites. The non-profit organization Design Trust for Public Space estimated that the amount of available area just under its elevated tracks and roadways is nearly four times the area of Central Park.[xiii] Although New York City already has 20 percent of its land area specifically allotted to parks and public open space, there is a vast potential for New York City to be optimized and offer more aesthetically-pleasing and ecologically productive open space.[xiv] Currently, there are a lot of underutilized areas that, if properly developed with accessible green space, afford the opportunity for New York City to become a model for the 21st century of how cities can increase density while maintaining livability.

Phoenix is a more of a typical *horizontal city*—almost the inverse of Shanghai's verticality in its length and spread. Although it's one of the fastest growing urban centers in America, it's normal to live within the Phoenix city limits while maintaining a traditional, suburban lifestyle. With its endless array of planned communities and cul-de-sacs, there is a heavy dependence on cars for transportation and less emphasis on the walkable lifestyle you find in denser metropolis centers. Horizontal cities, like Phoenix, tend to be newer, with warmer climates and offer direct access to important amenities like nearby wilderness areas.[xv] The landscape in Phoenix is omnipresent—with the surrounding mountains always in view and the desert that drifts in along roadway edges and sparks an ephemeral beauty with the shifting of light and season.

Wandering to Invoke the Wild

The practice of urban wandering can be a key factor in shifting perceptions about the value of spontaneous vegetation in the city. As a process, it leads to a subjective reinterpretation of the city, a series of individual, episodic observations that through their aggregation can lead to new conceptual relationships. This type of walking challenges the objectivity believed to be inherent in traditional cartography and suggests a new way of mapping based on individual perception. When applied to the documentation of urban weeds, walking is a thread that can connect each individual plant observed to a greater whole, uniting the disparate spaces and making the case for a patchwork ecology.

In Detroit now, the groundswell shift from more structure to more voids has fundamentally changed the way urban dwellers perceive and move through space. It has invoked a sense of exploration, open-endedness, and a freedom from the traditional hegemony of industrialism that dominated Detroit for the better part of the 20th century. Desire lines, created by walking, cross through open territory that had once been individual buildings and now are sequences of void space. Urban dwellers take the path of least resistance and are not bound by the use of traditional sidewalks, crosswalks, or private lot lines as the prescribed ways of moving through urban space. Although desire lines through public space are more prevalent on universities and campuses, which coincidently foster more individuality and creative exploration, walking as a practice of colonization of the *void city* is still unique and raises significant questions: Does the rise in individual autonomy and reclamation of urban space relate to a lack of population density? What programmatic activities are city inhabitants pursuing in this new open space? Are there productive uses for the landscape that can be employed like fruit tree orchards, urban agriculture, or foraging from spontaneous vegetation? How does this change the ways dwellers use, experience, and understand their city's relationship to nature? A walker in the *void city* might draw on the freedom they experience by the lack of artifice and apply that sense of immensity and limitlessness to a new territory. Investigate the dead end street. Occupy vacant lots. Climb over fences to walk along the water's edge. Don't use the sidewalks but cut through backyards. Inhabit the streets. Reclaim territory through walking.

In contrast, movement in New York City is still highly prescribed. The sheer density of people, cars, and buildings creates a series of obstacles to move around and respond to. I walk out of my front door in Park Slope, Brooklyn and I walk five steps forward and hit the front railing. I turn right and take two steps forward then I turn left and walk two steps forward through the gate until I'm in the middle of the sidewalk. I turn left and take about 50 steps to the stoplight at the end of the block. I turn right, wait for the light, and then walk across the crosswalk. Every motion is orchestrated. There is very little freedom within the system of pedestrian movement that most parts of the city offer. Running through nearby Prospect Park or wandering around our office down in Red Hook, Brooklyn offers more openness and a greater flexibility in the way a user might inhabit space.

In Phoenix, city-dwellers walk out of their single-family stand-alone house, to the end of their subdivision's cul-de-sac, and out into the boundless desert. There is no path or prescribed movement through space in the desert. It's a limitless territory where a visitor can wander in any direction that they want without any indication of what should lead them from one place to another. The desert is a sort of *first nature* with its expansiveness sitting in awkward juxtaposition to the constructed landscape of adjacent low-rise strip malls.

Theory of the Dérive

The process of traversing the urban landscape by foot has been used through the ages to confront the status quo, from activists marching against political issues to artists using walking as an aesthetic practice. Guy Debord, a Parisian philosopher and Dadaist, founded a movement called Situationism, which explored the poetic relationship between geography and psychology within the context of the imaginative potentials in the urban environment. In his short essay originally published in 1953, "Theory of the Dérive," Debord defined psychogeography as "the study of the precise laws and specific effects of the geographical environment, whether consciously organized or not, on the emotions and behavior of individuals."[xvi] These phenomena were studied by a series of walks or explorations into the urban milieu. The Situationist's intentions were to understand the city's "constant currents, fixed points, and vortexes which strongly discourage entry into or exit from certain zones."[xvii] Confronting society's blind acceptance of the urban environment, the Situationists engaged in collective art forms known as *dérives*—experimental walks through the city in which the walker subconsciously makes navigational decisions based on subtle variations in the psychogeographic landscape of the city. *Dérive* means "to drift"—a practice Debord defined as, "one or more persons during a certain period, drop their usual motives for movement and action, their relations, their work and leisure activities, and let themselves be drawn by the attractions of the terrain and the encounters they find there."[xviii] From those walks he later developed mind mappings of the walks. His 1957 work, *Mémoires*, depicts a disjunctured city where city-islands existed in only episodic moments—a map where things are not literally dimensioned or

"accurate" representations of physical space, but where void spaces allow for an infinite amount of possible cities to emerge.

Andrei Tarkovsky's 1979 film *Stalker* takes Debord's concepts of *dérive* and integrates the role of nature as a raw, powerful, scary, and sacred force into the conversation. In the film, landscape is represented as wild and overgrown—reclaiming what had been a place of human habitation. Set in a seemingly post-apocalyptic world, Tarkovsky created a beautiful film about "the essential human element that forms like a crystal in the soul."[xix] He uses landscape as a metaphor for this inner power and as the context through which a soul's narrative unfolds. To bring it to a contemporary context, the film feels like ABC's *Lost* meets Beckett's *Waiting for Godot*. The viewer feels like there is a deeper significance that is unfolding as the characters and film progress—a kind of search for meaning that perhaps is never quite realized. As it turns out, the film is rather prescient and predated man-made nuclear disasters like Chernobyl in 1986 and Fukushima in 2011. Coincidentally, roughly thirty years after the incident, Chernobyl's exclusion zone around its nuclear reactor looks a lot like the overgrown, uninhabited landscape represented in *Stalker*.

The film's setting is an area ominously called The Zone—an off-limits territory at the urban fringes. A stalker leads two seekers through The Zone on a quest to find the place where your "deepest wish will come true." Movement through this wild is highly prescribed, as the stalker determines the route by ritualistically throwing a cloth bag with nuts and following where it lands, and notes that straying from the path could be dangerous. In Tarkosky's work, the *dérive* becomes a metaphysical journey through an altered and degraded nature.

One might argue that, before *Stalker*, filmgoers hadn't really seen post-industrial landscapes represented in this way. Nature was typically presented as pristine and idyllic, but in the film the man-made and natural blend together seamlessly, hardly distinguishable before the viewer's eyes. The landscape in "Stalker" left a deep imprint on my own psyche, and made me recall the abandoned railroad tracks behind the subdivision where I would wander in my youth. The tracks, like the streambed and tunnel culverts under the train and highway, were areas that invoked a boundless sense of freedom in my twelve-year-old self. The railroad tracks hadn't been used in years and weeds were taking over—thorny red thickets, wild grasses, and ephemeral wildflowers made the infrastructure dissolve into nature.

Through the realization of a Situationist city, Debord aimed to bring about a world-transforming revolutionary spirit. If our current psychogeographic lens could be focused on the mundane—perhaps the diminutive plant emerging from the sidewalk crack—a similar transformative process might unfold. Provocative, engaging plants or landscape vignettes can serve as the inspiration for what might push and pull an urban dweller through space. This shift towards using the landscape

as a generator of movement throughout the city has the potential to highlight latent poetic sensibilities and shift perceptions about the value of urban landscapes.

Optimizing the Found Object

The art historical context for the appreciation of the mundane begins even before Debord's exploration, with Marcel Duchamp's readymades. Art critic Calvin Tompkins writes in his biography, *Duchamp*, about "a bottle-drying rack, a snow shovel, and other manufactured items that Duchamp promoted to the status of works of art simply by selecting and signing them."[xx] This simple idea that art could be a mental act rather than a physical one became one of the primary foundations of modern conceptual art in the 20th century.

In an interview in 1973, land artist Robert Smithson criticized Duchamp's approach to his readymades claiming he offered a "sanctification for alienated objects" and that his manufactured objects "are just like relics…some kind of spiritual pursuit that involved the commonplace."[xxi] Smithson rejected this notion of transcedence, asserting that his own work with Non:Sites explored a dialectic relationship between object and the outside world. His Non:Site gallery installations included mappings and collected rocks from distant, human-altered landscapes. "These Non:Sites became maps that pointed to sites in the world outside the gallery, and a dialectical view began to subsume a purist, abstract tendency."[xxii] By reframing the vast landscape of a faraway site within the intimate confines of the blank space of an art gallery, Smithson thought his artwork was less about alchemy and more about exploring the idea of subjectivity. This democratic view seems less didactic than Duchamp's approach—where art isn't about reaching conclusions but rather about revealing latent potentials and allowing for multiple meanings to emerge based on individual perceptions.

Designing with Weeds

As we begin to better understand the art historical precedents, themes of landscape urbanism, and the way that wandering in our contemporary city can help us reframe perceptions, we can draw on our knowledge to design a sustainable urban future. Careri writes, "...walking is useful for architecture as a cognitive and design tool, as a means of recognizing a geography in the chaos of peripheries, and a means through which to invent new ways to intervene in public metropolitan spaces, to investigate them, and make them visible."[xxiii] From our perspective as landscape urbanists and designers, there is a need to reveal the potential of our spontaneous urban landscapes and create a dialectic about their value and beauty.

By utilizing wild urban plants, we can design with a palette of greenery adapted to disturbed soils, widely available and attractive to pollinators and other wildlife. An informed combination of these factors can help create a pleasant urban meadow. As much as the upfront plant selection needs to play an important role, some designing will come through the process of subtraction. By removing diseased

plants, those planted too close together, or even the plants that are particularly unsightly or cause allergic reaction, designers can help to make the wild urban meadow tidy and kempt—and more appealing. Through processes of subtraction, addition, optimization, and replication, the patchwork ecology of widespread spontaneous vegetation will enable the emergence of a more resilient, adaptable, and sustainable urban future.

In operating on the city, our architectural strategy at Future Green Studio is to analyze its social, ecological, and historical systems and draw conclusions that allow us to develop a set of typologies that can be rolled out on the city in ways appropriate to the site specific conditions, the inherent sensibilities, and psychogeographic dynamics of the city. We need to recognize the small-scale interventions of green infrastructure where traditionally underutilized spaces—like walls, roofs, and streets—can be utilized in innovative ways to create both aesthetically and ecologically performative spaces. These micro-interventions together through their aggregation become a functioning ecology that helps to create a more livable and sustainable city.

In order to understand the future of ecological urbanism as we encounter climate change, we are going to have to study the vegetative systems that are most successful now in our harshest urban conditions. These weeds are the first invaders of a radical new nature that subverts from the ground up the autocratic systems of urban renewal we like to call "progress." In this case, traditional perceptions are meant to be broken. There is no original nature to preserve. Nature is by its very existence a dynamic force that is constantly reinventing itself.

We've evolved through history understanding these layers of nature that exist between ourselves and the world around us. Traditionally the horizontal juxtaposition of artifice to nature—from house, to garden, to fence, to fields, and then to the distant mountaintop—unfolds and stretches out across our view. As we move into the 21st century, what we are now beginning to understand is that, because we've colonized nearly everything, that sense of the sacredness of *first nature* is disappearing. At the same time, perhaps there is some sort of inversion that is happening as we look for that *first nature* from within. Completely intertwined with our urban territory, spontaneous plants are the foundation of our future garden cities. Maybe that sacred wild is emerging right underneath our feet?

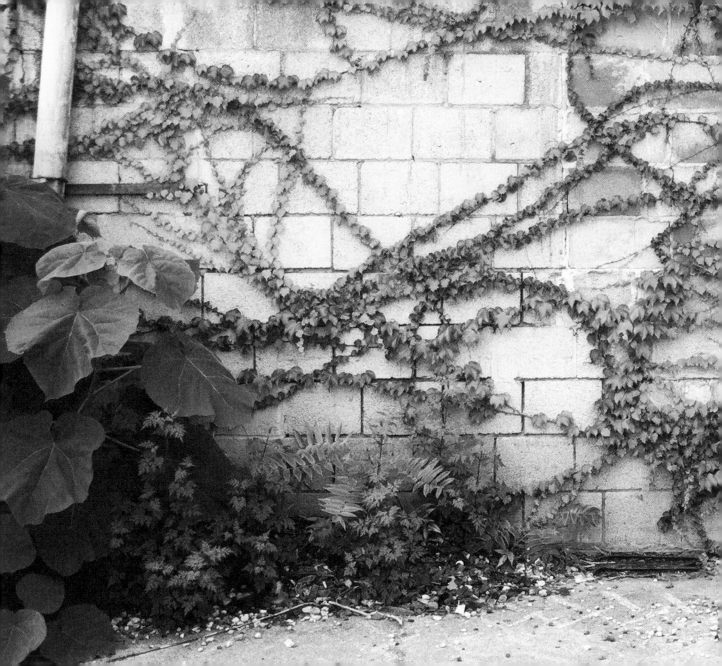

A PHOTOGRAPHIC INDEX OF SPONTANEOUS URBAN PLANTS

UPPER EAST SIDE, MANHATTAN, NYC
40°43' N, 73°59' W

WEEKEND MORNING IN EARLY FALL. IT'S A PERFECT DAY. THE AIR IS CRISP AND THE SUNLIGHT FEELS WARM. THIS PART OF TOWN MARGINALIZES ITS WEEDS TO THE EDGES. THE WAY THE CITY MEETS THE PARK ALLOWS FOR SOME VOLUNTEERS. THE KIDS JOIN ME FOR PART OF THE WALK WITH THE PROMISE TO STOP FOR BRUNCH AT A DINER ALONG THE WAY.

WEATHER : SUNNY AND COOL
DURATION : 02:28:11

CENTRAL

Paulownia tomentosa

PARK

Morus alba

SIDE

Ailanthus altissima

YORKVILLE

EAST SIDE

CENTRAL PARK SOUTH

CARBON SEQUESTRATION
noun /ˈkar·bən , sikwəˈstrāSH(ə)n/

RISING LEVELS OF CARBON DIOXIDE IN THE ATMOSPHERE ARE CONTRIBUTING TO GLOBAL WARMING AND RAPID CLIMATE CHANGE. PLANTS ARE THE GREATEST NATURAL RESOURCE WE HAVE TO WARD OFF THIS IMPENDING THREAT. THROUGH PHOTOSYNTHESIS, THEY PROVIDE US THE UNIQUE SERVICE OF REMOVING CO_2 FROM THE ATMOSPHERE, STORING IT IN THEIR STEMS, ROOTS, AND WOOD, AND USING IT TO PRODUCE ENERGY FOR GROWTH. WITH THEIR LARGE BIOMASS AND WOODY STRUCTURE, TREES ARE OFTEN THE MOST EFFICIENT CARBON CAPTURING PLANTS. THIS IS ESPECIALLY TRUE IN YOUNG, EMERGENT FORESTS, WHERE THERE IS STILL AN INCREASE IN THE BIOMASS BEING PRODUCED. METRICS HAVE BEEN ESTABLISHED TO ADD VALUE TO THE ACT OF URBAN TREE PLANTING AND TO CHART THE ABILITY OF TREES TO MITIGATE THE EFFECT OF FOSSIL FUEL EMISSIONS. QUICK GROWING SPECIES ARE FAVORED AND ARE REPRESENTED BY MANY SPECIES IN THE URBAN FLORA.

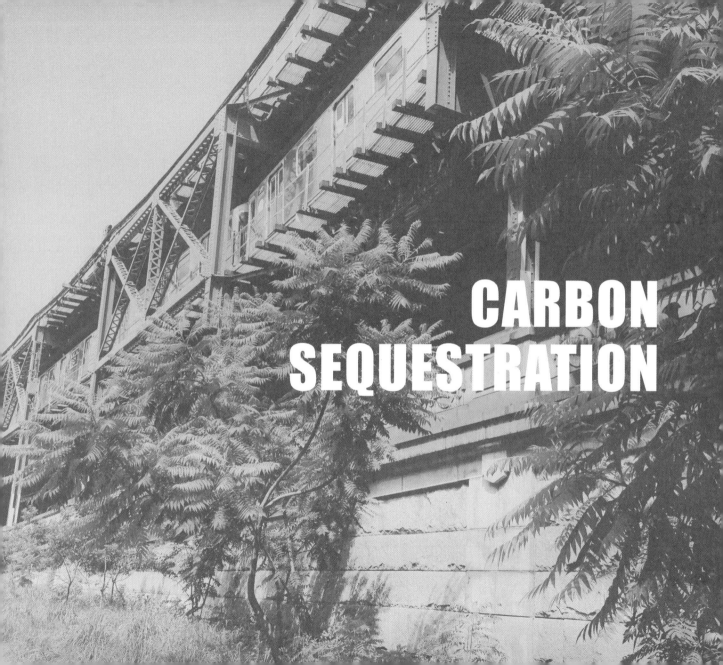

CARBON
SEQUESTRATION

AILANTHUS ALTISSIMA
Tree of Heaven

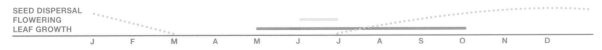

SEED DISPERSAL											
FLOWERING											
LEAF GROWTH											
J	F	M	A	M	J	J	A	S	O	N	D

Introduced to the US for ornamental purposes in the 18th century, tree of heaven is the most ubiquitous weed tree species and is generally found in forgotten urban niches where other plants would struggle for survival. The tree was famously used as a poignant metaphor in Betty Smith's *A Tree Grows in Brooklyn* for its ability to adapt and tolerate adverse growing conditions. *Ailanthus altissima* can release chemicals through its roots that can inhibit the growth of other species. The plant's ability to grow quickly, six feet or more a year in the northeast, renders it an important urban tree, and a powerful carbon capturing species. Capitalizing on the plant's fast growth and tenacity, *Ailanthus* has also been used in phytoremediation tests in which the tree's roots slowly remove toxins from the soil and store them in its woody mass. Although New York State recognizes *Ailanthus* as an invasive species, it has an historical record of providing other human and ecological services, such as shade in underserved neighborhoods. The tree possesses compound leaves that imbue it with a tropical appearance, especially when its dense seed clusters turn coral in late July. The numerous seeds spiral around in the air as they ripen later in the autumn.

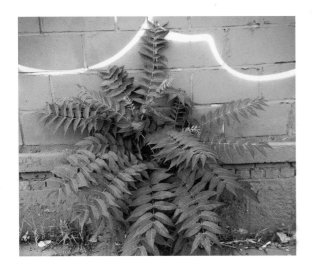

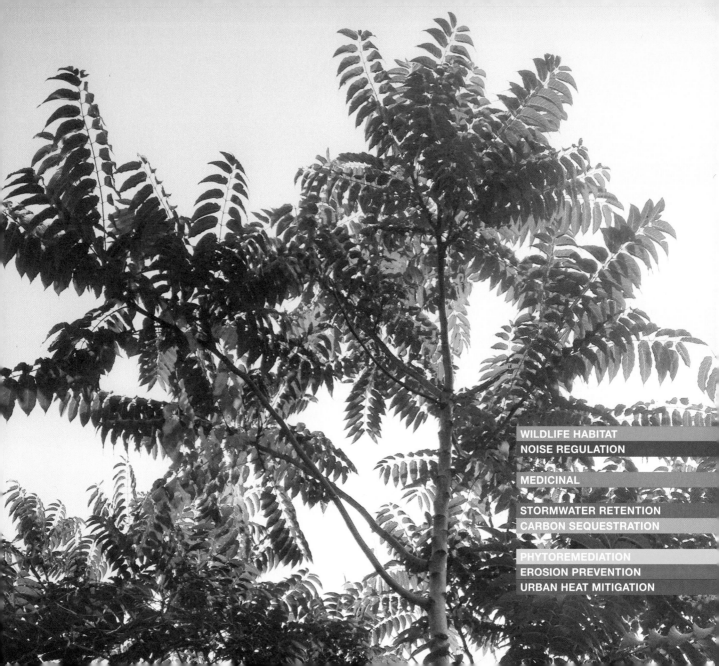

WILDLIFE HABITAT
NOISE REGULATION

MEDICINAL

STORMWATER RETENTION
CARBON SEQUESTRATION

PHYTOREMEDIATION
EROSION PREVENTION
URBAN HEAT MITIGATION

PAULOWNIA TOMENTOSA
Princess Tree

SEED DISPERSAL
FLOWERING
LEAF GROWTH

J F M A M J J A S O N D

Princess tree is a glamorous ornamental addition to the urban flora with its tubular flowers appearing a few weeks before the leaves in spring, dressing the slender "Princess" in lilac panicles nearly a foot long. Over winter, the unusual and beautiful candelabra-like flower buds are sheathed in short, ochre hairs. The beauty of the flowers is in sharp contrast to the places it is usually found growing, such as in abandoned lots and amidst rubble. *Paulownia tomentosa* is a deciduous tree species typically found in disturbed habitats with ample light conditions. Its velvety, large leaves can reach a foot across. Young or immature plants often possess foliage that is twice as large as leaves on mature specimens and have been used as coppice plants in ornamental gardens to foster this character. Timber from the princess tree is prized in Japan and China where it is used for ornamental carving and in the construction of musical instruments. *Paulownia tomentosa* is a remarkably fast-growing tree producing seeds at the young age of five to eight years, which contribute to the plant's identity as a pioneer species. Quick to sprout and flourish, the tree's rapid growth enhances its ability to capture carbon in the urban environment.

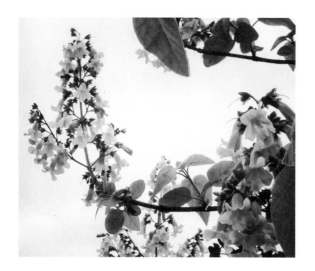

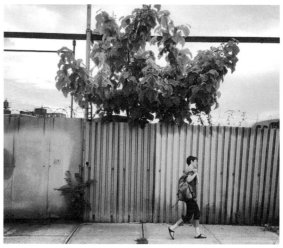

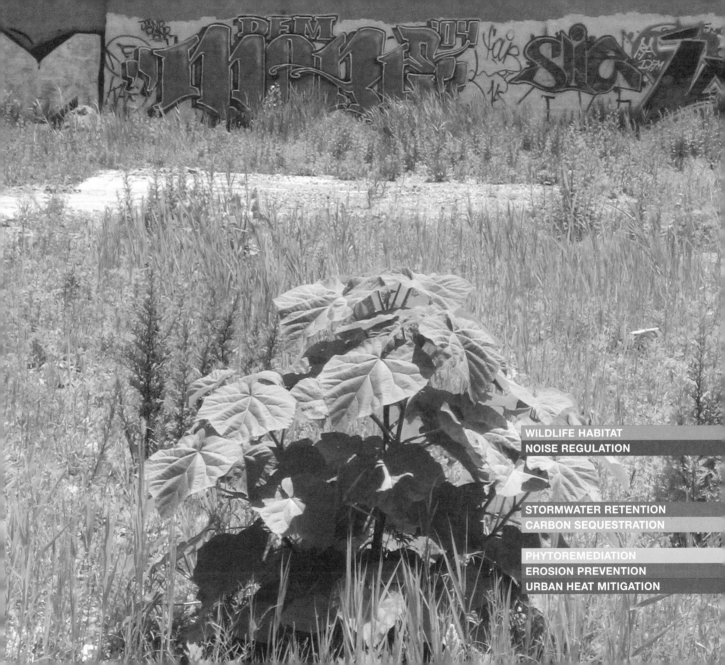

WILDLIFE HABITAT
NOISE REGULATION

STORMWATER RETENTION
CARBON SEQUESTRATION

PHYTOREMEDIATION
EROSION PREVENTION
URBAN HEAT MITIGATION

MORUS ALBA
White Mulberry

SEED DISPERSAL
FLOWERING / FRUIT
LEAF GROWTH

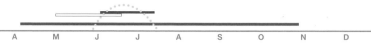

J	F	M	A	M	J	J	A	S	O	N	D

Morus alba is a small deciduous tree that originated in China and has since been cultivated throughout the world. It was grown in the United States initially for the purpose of establishing a silkworm industry, as mulberry leaves are the preferred food source for the silkworm. Growing to a mature height of fifty feet, white mulberry's fast growth rate makes this a powerful carbon-capturing species in the urban environment. Found on roadsides, disturbed sites, and along chain-link fences and unmaintained tree pits, mulberry also inhabits flood plains and riparian areas. *Morus* can tolerate high salt levels, drought, and pollution to a degree unmatched by all but the *Ailanthus*. Bark and roots of young trees have an orange tint which can help to identify the tree. Insignificant flowers develop into pink or black fruits produced by the tree without restraint to the chagrin of those who dislike the stains the berries leave behind. The fruits of white mulberry are popular ingredient for jams, pies, and cookies, and as fresh or dry berries. The leaves are used to make tea and have been recommended in traditional Chinese medicine throughout history. The fruits are also a valuable food source for many birds that help to disperse the tree's seeds.

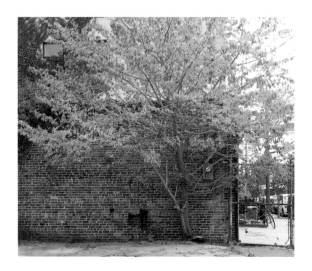

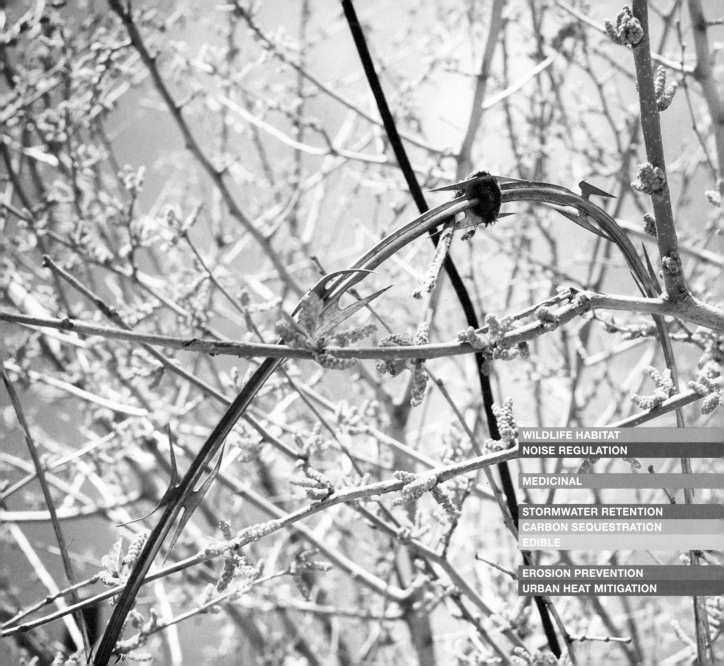

WILDLIFE HABITAT
NOISE REGULATION

MEDICINAL

STORMWATER RETENTION
CARBON SEQUESTRATION
EDIBLE

EROSION PREVENTION
URBAN HEAT MITIGATION

HUNTS POINT, BRONX
40°48' N, 73°52' W

EARLY MORNING IN SPRING, THE FAMILIAR SOUND OF HEAVY TRUCKS RUMBLING BY. THERE IS AN OPENNESS AND EXPANSIVENESS HERE THAT COMES WITH THE LOW-RISE, LIGHT INDUSTRIAL BUILDINGS. THE SUN IS VEILED. ITS LIGHT IS DEFLECTED, SOFT AND GREY. THE RAIN IS NOT BOTHERSOME OR OPPRESSIVE, BUT A GENTLE REMINDER OF THE CLEANSING QUALITY OF THE NEW SEASON. PLANTS ARE JUST WAKING UP AND PICKINGS ARE RATHER SLIM.

WEATHER : RAINY WITH OVERCAST SKIES
DURATION : 02:41:07

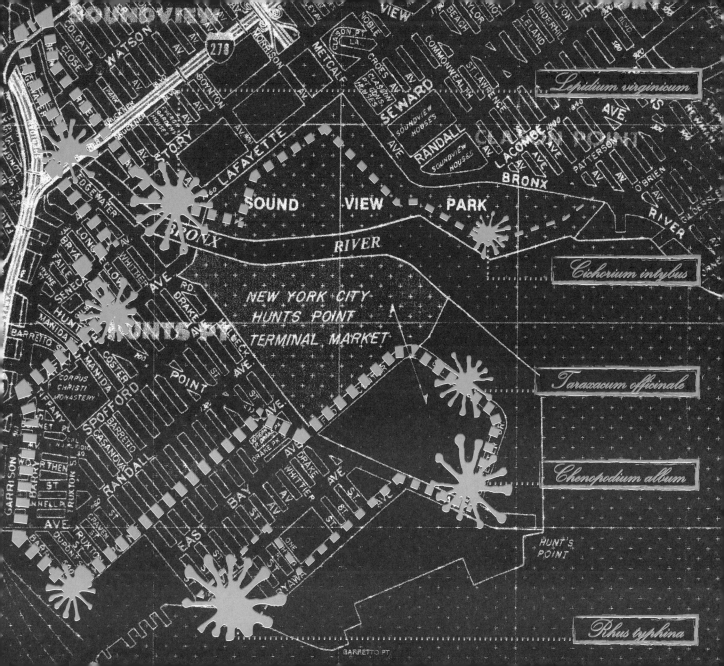

SOUNDVIEW

CLASON POINT

Lepidium virginicum

SOUND VIEW PARK

BRONX RIVER

NEW YORK CITY
HUNTS POINT
TERMINAL MARKET

Cichorium intybus

Taraxacum officinale

Chenopodium album

HUNT'S
POINT

Rhus typhina

BARRETTO PT

EDIBLE
noun / ˈed·ə·bəl/

THE RISE OF INDUSTRIAL SCALE FOOD PRODUCTION HAS DISCONNECTED THE CONSUMER FROM THEIR REGIONAL FOOD SOURCES. THE LACK OF ACCESS TO LOCAL FOOD, ESPECIALLY IN LOW-INCOME URBAN AREAS, HAS BECOME A NATIONAL SOCIAL JUSTICE AND HEALTH CARE ISSUE. AT THE SAME TIME, THERE HAS BEEN A RESURGENCE OF INTEREST IN FRESH FOOD THROUGH AN EXPOSURE TO GREEN MARKETS AND COMMUNITY-SUPPORTED FARMS. ADDITIONALLY, URBAN FORAGERS HAVE HELPED TO REVIVE THE PRACTICE OF HARVESTING WILD PLANTS. MANY NUTRITIOUS AND DELECTABLE FRUITS, SHOOTS, AND GREENS CAN BE FOUND AND REQUIRE LITTLE OR NO CULTIVATION. WILD URBAN PLANTS SUCH AS MULBERRY OR SUMAC ARE BEING REEVALUATED FOR THEIR DELICIOUS FLAVOR, LOCALNESS, AND ABUNDANCE.

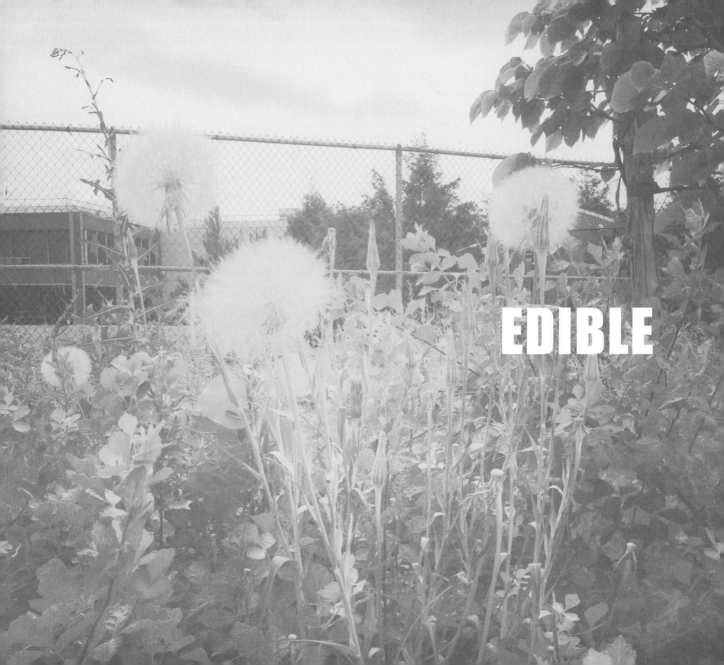

EDIBLE

CICHORIUM INTYBUS
Chicory

SEED DISPERSAL
FLOWERING
LEAF GROWTH

J F M A M J J A S O N D

Cichorium intybus is an erect, perennial herb that can be found in median strips, vacant lots, seams of cracked pavement, and along roadsides—all conducive habitats due to its ability to tolerate highly alkaline soils and drought. Chicory is unmistakable with its deep sky-blue flowers on wiry, leafless stalks that can rise up to five feet—a meadowy spectacle along roadways as it blooms side by side with Queen Anne's lace. Flowers only open in the bright sunshine of summer mornings and often fade before noon. A basal rosette of leaves resembles dandelion foliage, with the same milky sap and a fleshy taproot.

Chicory has been cultivated for human consumption for millennia, bred to enhance particular characteristics, as in the cultivated variety of chicory known as endive. The leaves can be sautéed and blanched, and is a popular vegetable combined with pasta in parts of Europe for flavor. The young leaves and blossoms can be used in salads most times of the year. Its thick roots have been roasted and ground as a coffee substitute and is the flavoring found in "French Roast" blends. This multipurpose plant contains high amounts of proteins, carbohydrates, and minerals and boasts of medicinal properties.

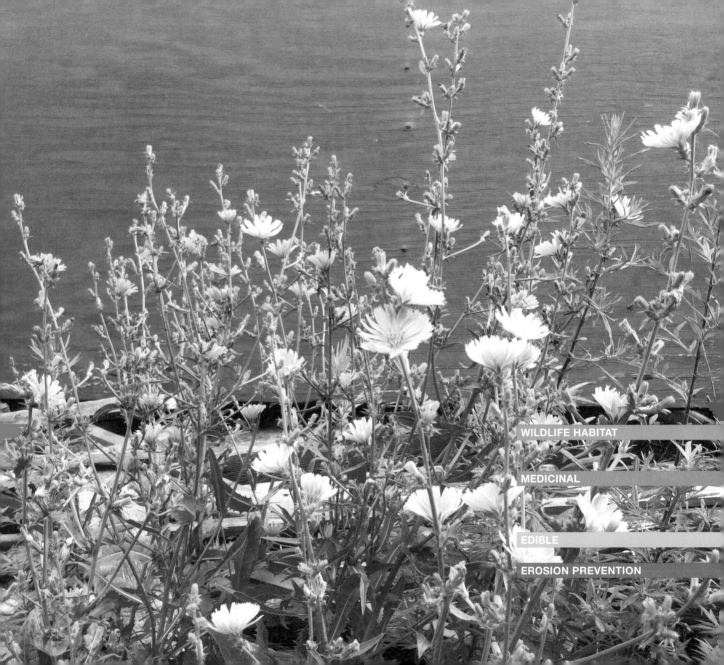

WILDLIFE HABITAT

MEDICINAL

EDIBLE

EROSION PREVENTION

LEPIDIUM VIRGINICUM
Virginia Pepperweed

SEED DISPERSAL
FLOWERING
LEAF GROWTH

| J | F | M | A | M | J | J | A | S | O | N | D |

Virginia pepperweed, or poor-man's pepper as it is known colloquially, is a short biennial that colonizes bare, sandy soil in sunny spots like tree pits, along roadsides, and in vacant lots. *Lepidium* is native to the Eastern US. It develops a taproot which helps it withstand drought conditions and poor soils. The plant remains relatively inconspicuous until the emergence of its spring flowers. Small, dense spikes of white-green raceme flowers emerge as beautiful bottle-brushy specimens through the dense growth of the highly branched and hairy-stemmed plant. The small flowers continue to bloom at the end of the spike through August, as they develop small, flattened seed pods lower on the stalk. Traditionally used by Native Americans for medicinal purposes like treating poison ivy rash, scurvy, and croup, the species is now known for its edible seeds and foliage. Young leaves rich in vitamin C can be consumed raw or cooked and have a spicy, cress-like flavor. The seed pods are used in lieu of pepper to flavor soup and stews. The leaves can be added to salads or used as a garnish. Seeds are favored by many kinds of wildlife, including birds, that are partly responsible for the plant's wide dispersal.

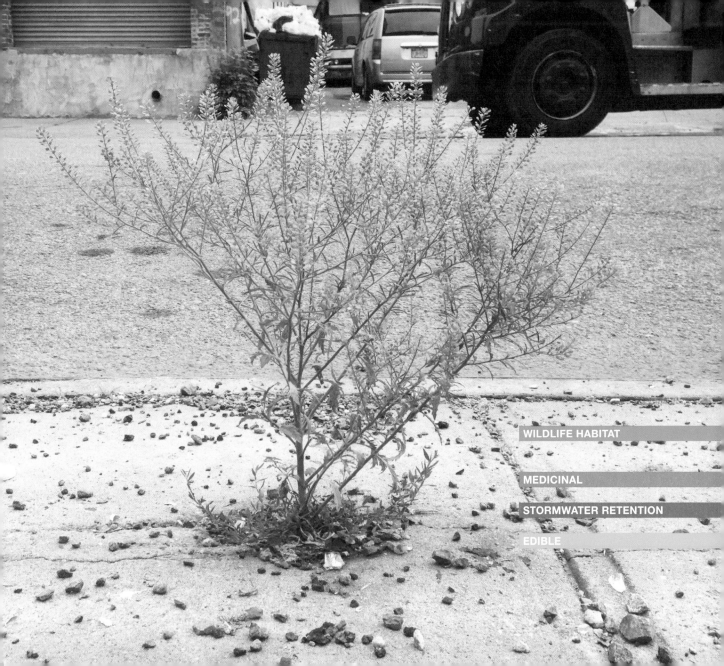

WILDLIFE HABITAT

MEDICINAL

STORMWATER RETENTION

EDIBLE

PORTULACA OLERACEA
Common Purslane

SEED DISPERSAL
FLOWERING
LEAF GROWTH

J	F	M	A	M	J	J	A	S	O	N	D

Portulaca oleracea can easily be spotted as one of a few succulent plants that inhabit urban environments. Fleshy oval leaves are mostly found in clusters at the ends of prostrate branches and at stem joints. It forms a spreading mat that hugs the ground, no higher than six inches tall. It is commonly found in small pavement cracks, taking advantage of the extra heat this niche provides. From July through September, yellow flowers bloom, open for only a few hours on sunny mornings. Despite this bashful flowering, *Portulaca* produces large amounts of seed, held by little, capped pods. While preferring nutrient-rich, sandy soils, all parts of purslane, including its leaves, can store enough moisture to sustain a plant through drought, enabling the plant to survive otherwise inhospitable site conditions. Purslane is commonly eaten in Europe, Mexico, and the Middle East as a delicious leafy green, rich in dietary fiber and vitamins. The succulent leaves and tender stems have a sour and salty taste and are an excellent source of Omega-3 fatty acids. They can be used in salads, cooked as spinach, in soups, and as a garnish. It is not uncommon to find the plant incorporated into salads at trendy, cosmopolitan restaurants.

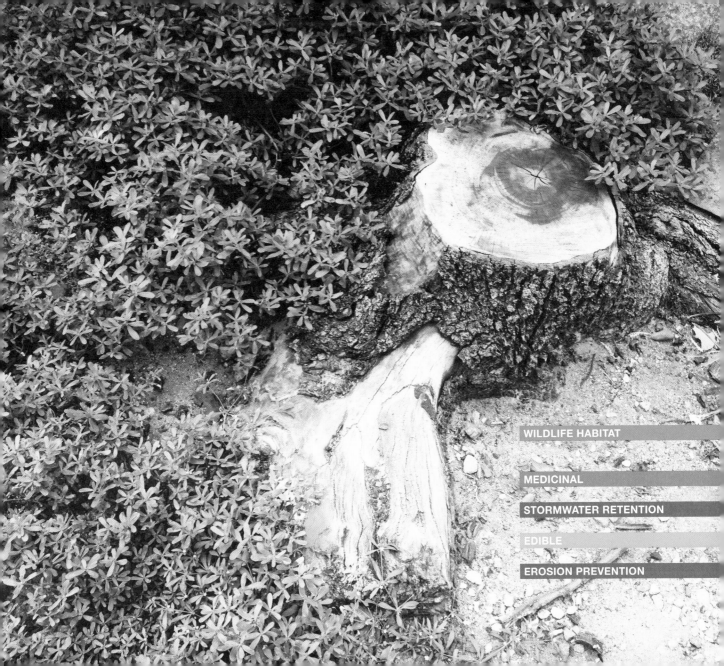

WILDLIFE HABITAT

MEDICINAL

STORMWATER RETENTION

EDIBLE

EROSION PREVENTION

RUBUS PHOENICOLASIUS
Wineberry

SEED DISPERSAL
FLOWERING / FRUIT
LEAF GROWTH

J F M A M J J A S O N D

Rubus phoenicolasius is a species of raspberry native to Korea, Japan, and China. It was introduced to North America in 1890 as breeding stock for new raspberry cultivars and is still used today by berry breeders. It is typically found in the wild at woodland edges and along roadsides and railroad tracks. Wineberry is a perennial, multistemmed shrub that prefers sunny yet moist sites and spreads through its network of stems which root at their ends. It can form dense, shady thickets of prickly red stems, which limit the growth of other plants and make it undesirable to walk through. This suckering habit can also prove to be useful as the quick-growing, woody stalks capture carbon and its extensive root system prevents soil erosion on embankments. The shrub leafs out in sets of three, with leaves green on top and wholly white underneath. The fruits are very distinctive for their ruby-like character, and the red glandular hairs that cover the sepals that surround them. The attractive orange and red berries contain many seeds and are an excellent food source for birds, deer, and other woodland wildlife, fruiting well into late summer. The fruits are deliciously sweet and tart—perfect for making pies, jams, desserts, and wines.

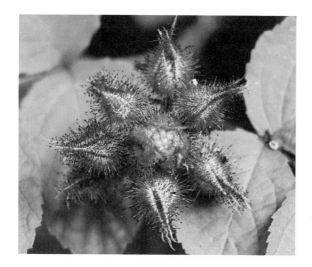

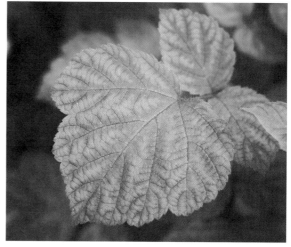

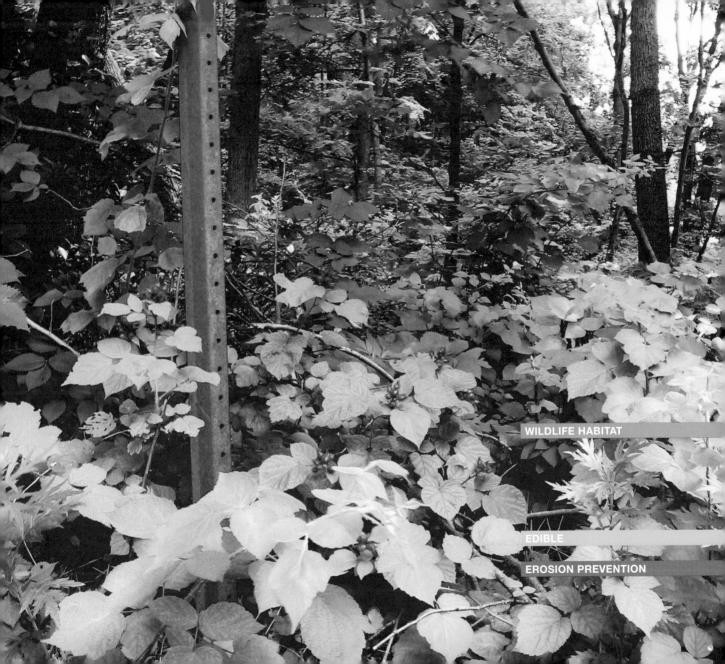

WILDLIFE HABITAT

EDIBLE

EROSION PREVENTION

TARAXACUM OFFICINALE
Common Dandelion

SEED DISPERSAL
FLOWERING
LEAF GROWTH

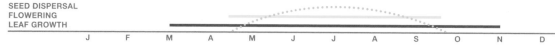

J F M A M J J A S O N D

Dandelions are a sunny, familiar addition to the urban flora. *Taraxacum officinale* are one of the world's most recognized weeds and invade the rich soils of cultivated places like suburban lawns as well as tough urban sites like sidewalk edges and open lots. Dandelion's ability to take root on cliffs in its native environment enables it to thrive in urban pavements. When situated within hardscaped areas and around storm drains, it offers the valuable service of slowing down stormwater runoff. The deeply lobed leaves and fleshy taproot contain bitter, milky juices, which many animals dislike, and help protect the plant from predation.

Introduced from Europe as a salad green in the mid-17th century, the leaves, root, and flower are eaten as tender, fresh greens, dried for tea, or used in the preparation of dandelion wine. It is a rich source of vitamin C, calcium, and magnesium, containing more vitamin A per plant than carrots or spinach. It has also been used in Europe as a medicinal plant for hundreds of years. Its ubiquitous golden flowers attract bees, butterflies, and children. Anyone who has ever blown on the spherical heads of a mature dandelion will know that the seeds are wind dispersed, and take flight via a feathery tuft of pappus.

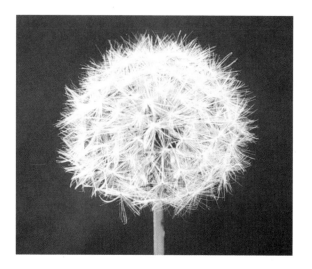

WILDLIFE HABITAT

MEDICINAL

EDIBLE

CHENOPODIUM ALBUM
Common Lambsquarters

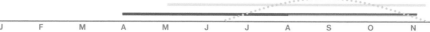

SEED DISPERSAL
FLOWERING
LEAF GROWTH

| J | F | M | A | M | J | J | A | S | O | N | D |

Lambsquarters is a plant tolerant of inundation, drought, and compaction. In urban areas, it's often found in tree pits, pavement cracks, and open meadows. Early to germinate in spring, this annual plant can grow to a height of nearly five feet and produce tens of thousands of seeds at maturity. Leaves and stems are dark green but are usually coated with a waxy, white powder which lent to its colloquial name of white goosefoot. Tiny stalk-less flowers, covered in the same white powdery substance as the leaves, are packed in dense clusters at the tips of the main stem and branches. Nutrient deficiency and stress is registered by the plant in its leaves and stems, which can turn a deep magenta color. The plant blooms continuously from June through November, and its seeds remain dormant in the soil for years. *Chenopodium album* is extensively cultivated for its culinary qualities in many parts of the world, featuring most prominently in cuisine of Northern India. Highly nutritious seeds are rich in protein, vitamin A, and calcium and are often dried and eaten raw, baked into bread, or added to salads. The young shoots and leaves are steamed like spinach and used in soups, curries, and breads.

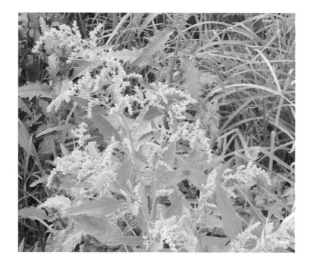

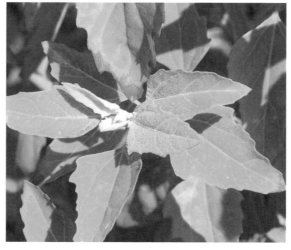

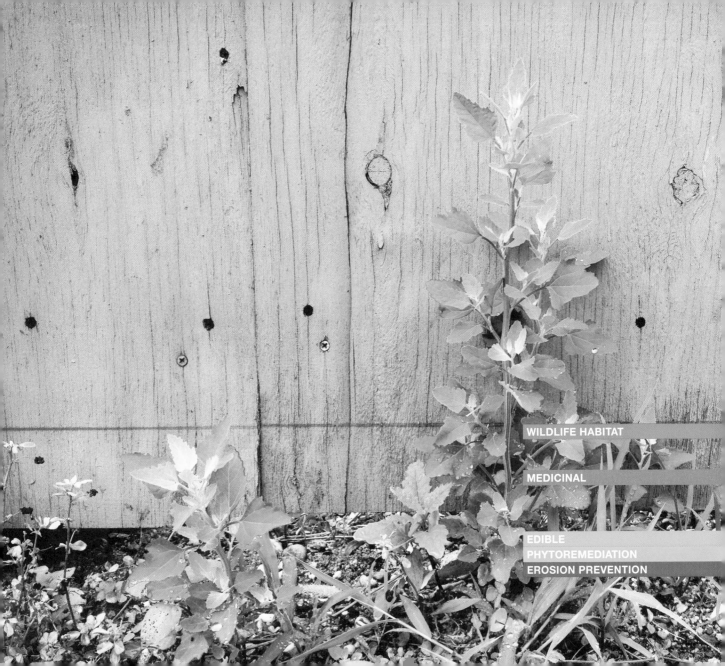

WILDLIFE HABITAT

MEDICINAL

EDIBLE
PHYTOREMEDIATION
EROSION PREVENTION

RHUS TYPHINA
Staghorn Sumac

	J	F	M	A	M	J	J	A	S	O	N	D
SEED DISPERSAL												
FLOWERING												
LEAF GROWTH												

Named for the resemblance of its velvety twigs to new deer antlers, staghorn sumac is much admired for its alternate pinnate compound serrated leaves, bright red fall color, and iconic cone-shaped red fruit that last from autumn until spring. *Rhus typhina* can be found along sunny woodland edges and road banks, in vacant lots, and in unmaintained public parks. It produces dense, green panicles of flowers in spring and stands in bold, red colonies in the fall that spread through their rhizomatous root system, with the thickets often reaching a height of twenty feet. The tallest plants are surrounded by a ring of younger suckers creating a mounded profile. These thickets stabilize soils and slopes while producing essential habitat and food source for wildlife. The brilliant red fruit clusters are consumed by birds and small mammals although they are often the last to be eaten after a long winter. Sumac seeds, when ground, can add a lemon-like flavor to foods and has been used as a spice in Middle Eastern cuisine. The berries can be immersed in water, steeped for a few hours, and made into a drinkable tonic. Berries can also be used in a variety of medicinal treatments and are valued for their astringent properties.

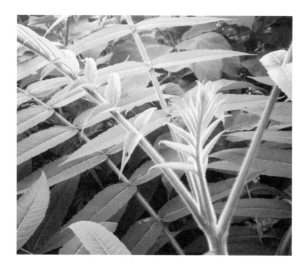

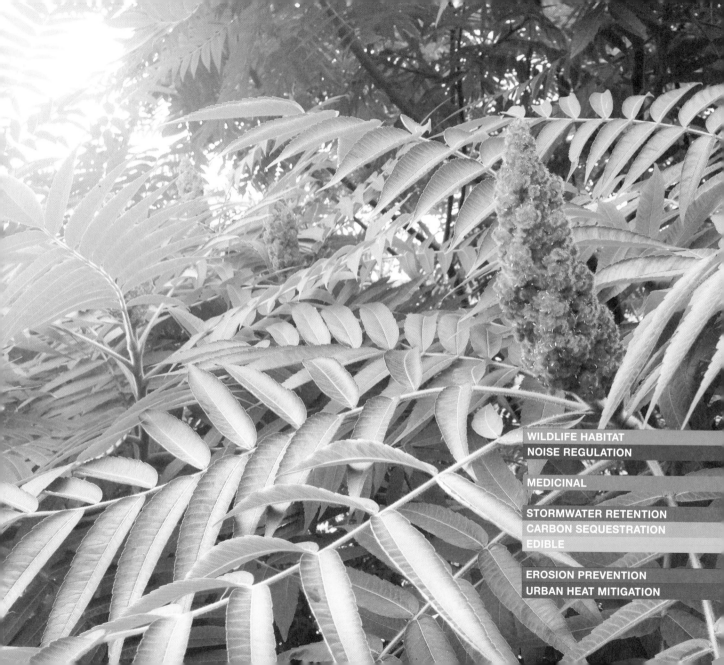

WILDLIFE HABITAT
NOISE REGULATION

MEDICINAL

STORMWATER RETENTION
CARBON SEQUESTRATION
EDIBLE

EROSION PREVENTION
URBAN HEAT MITIGATION

LOWER MANHATTAN, NYC
40°43' N, 74°00' W

HOT AFTERNOON IN SUMMER. THE WEATHER HAS BEEN DRY THIS SUMMER AND EVERYTHING LOOKS TIRED AND THIRSTY—INCLUDING ME. IT'S HARD NOT TO PEOPLE WATCH AND JUST FOCUS ON LOOKING FOR WEEDS. THE TIGHT NETWORK OF BUILDINGS OPENS UP ON THE WEST SIDE AND YOU CAN FEEL THE COOL AIR COMING OFF THE RIVER. THE ROADSIDE MEDIANS PROVIDE SOME GEMS.

WEATHER : HOT AND SUNNY
DURATION : 01:45:40

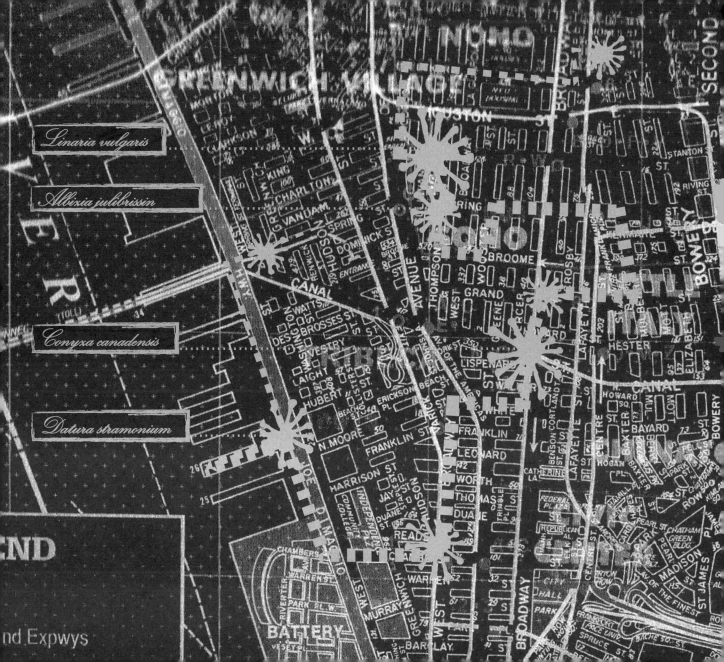

MEDICINAL
noun /məˈdɪs·ə·nəl/

THE STUDY OF THE MEDICINAL QUALITIES OF PLANTS LAID THE FOUNDATION FOR THE FIELD OF PHARMACOLOGY AND MODERN MEDICINE. THE GREEK PHILOSOPHER DIOSCORIDES WROTE THE AUTHORITATIVE TEXT ON MEDICINAL PLANTS, *DE MATERIA MEDICA*, IN THE 1ST CENTURY A.D. AND THE MANUAL WAS ACTIVELY USED FOR THE NEXT 1,500 YEARS. DEPENDING ON THE TYPE OF PLANT—ITS ROOTS, BARK, FOLIAGE, STEMS, FLOWERS, AND SEED CAN BE INTEGRATED INTO TOPICAL SALVES, REMEDIES, AND TINCTURES. THE COLLECTION OF WILD PLANT MATERIAL FOR MEDICINAL PURPOSES IS ONCE AGAIN POPULAR, IN PART BECAUSE OF A RENEWED FOCUS ON HOMEOPATHIC MEDICINE AND A GROWING DISTRUST OF LARGE PHARMACEUTICAL COMPANIES. RECENT STUDIES HAVE TAKEN STEPS TO VALIDATE HERBAL REMEDIES WITHIN THE CONTEXT AND RIGOR OF MODERN WESTERN MEDICINE.

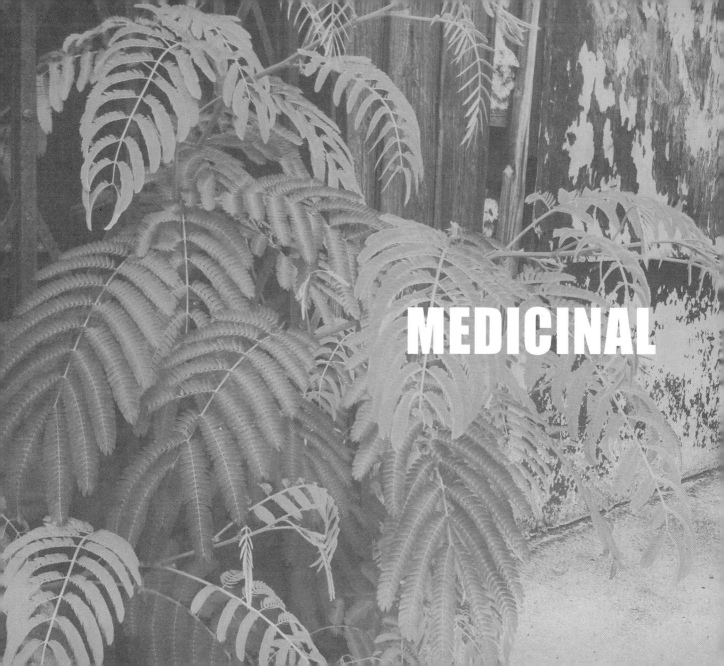

MEDICINAL

ALBIZIA JULIBRISSIN
Silk Tree

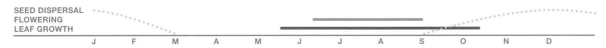

SEED DISPERSAL
FLOWERING
LEAF GROWTH

J F M A M J J A S O N D

The silk tree is a fast-growing, medium-sized ornamental tree with an enchanting umbrella-like form that is accented with "pom pom" flowers produced throughout the summer. *Albizia julibrissin* grows rapidly and is often considered a "pioneer" due to its ability to grow in poor soils, generate root suckers when damaged, and its resilient reproductive process that allows seeds to lay dormant for several years. Despite its adaptive abilities, which include tolerance of wind, salt, and drought, *Albizia* is never found with the abundance of other urban trees such as *Ailanthus*. It is always something of a delight to find such a delicate, glamorous tree emerging spontaneously in the city. Also known as the Persian silk tree, or mimosa tree, it was named for its showy flower cluster of pink silk threads. The sweet-smelling flowers are a good source of nectar for bees, butterflies, and hummingbirds. In some cultures, *Albizia julibrissin* is also referred to as a "night sleeper" due to its ephemeral habit of closing its leaves during the night. The tree has many uses in traditional Chinese medicine: dried flowers and bark are infused in a tea that is used as a digestive, carminative, sedative, and for the treatment of insomnia, irritability, and breathlessness.

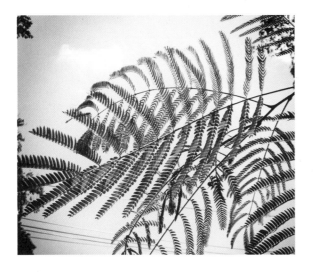

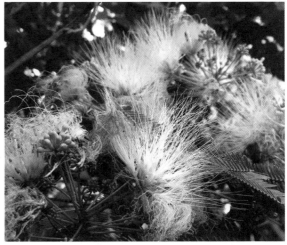

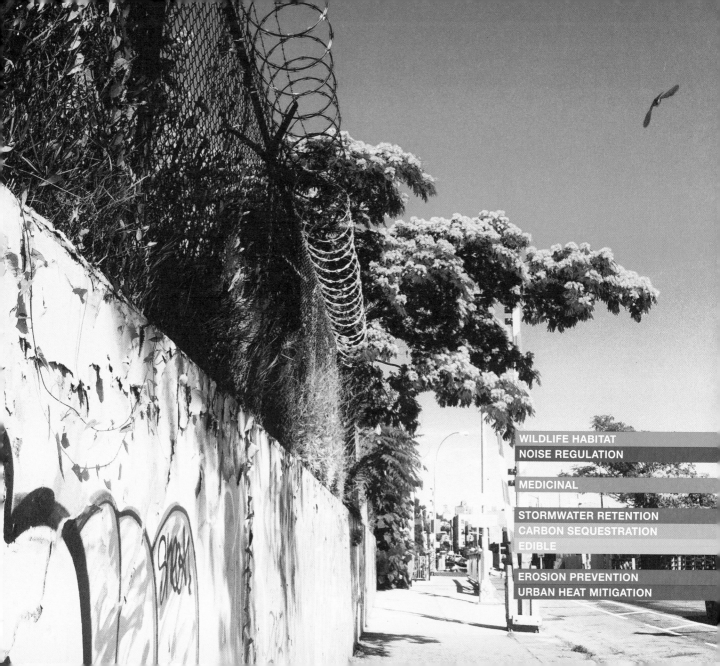

WILDLIFE HABITAT
NOISE REGULATION

MEDICINAL

STORMWATER RETENTION
CARBON SEQUESTRATION
EDIBLE

EROSION PREVENTION
URBAN HEAT MITIGATION

PLANTAGO MAJOR
Broadleaf Plantain

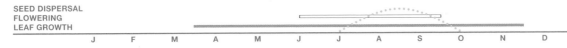

	J	F	M	A	M	J	J	A	S	O	N	D
SEED DISPERSAL												
FLOWERING												
LEAF GROWTH												

Plantago major is one of the early species to have naturalized in North America from the old world, spreading along with human movement on the new continent. Broadleaf plantain is quite common in urban areas where it thrives in sunny, moist, and fertile places as well as on dry sites and along compacted pathways, open park lawns, and drainage ditches. The leaves form basal rosettes and it can easily be identified by its parallel venation, unusual for a plant that is not a grass. Its attractive, rounded leaves shade the ground in the immediate vicinity of the plant, discouraging the growth of competitors, and enabling it to form small colonies. Flower stalks are slender, blunt spikes of a light green color from three to twelve inches tall and are wind-pollinated. Broadleaf plantain is known as a highly nutritious wild edible plant, rich in protein, beta carotene, and calcium. The young leaves are edible raw or cooked and can be added to salads. Dried leaves make a herbal tea. Not just consumed by humans, it is also an important food source for wildlife such as butterflies and caterpillars. *Plantago major* also has many medicinal uses, possessing compounds that fight infection, stimulate cell growth, and facilitate the healing of wounds.

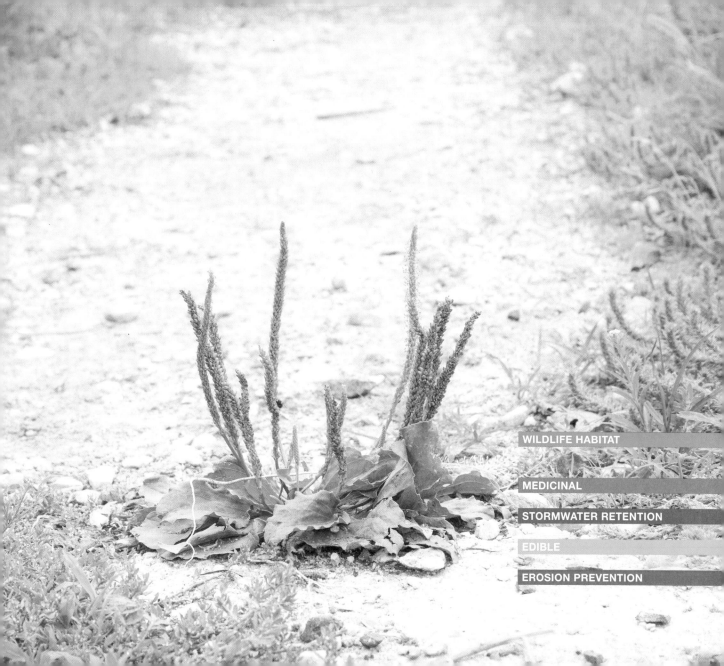

WILDLIFE HABITAT

MEDICINAL

STORMWATER RETENTION

EDIBLE

EROSION PREVENTION

LINARIA VULGARIS
Common Toadflax

SEED DISPERSAL
FLOWERING
LEAF GROWTH

J F M A M J J A S O N D

Linaria vulgaris is one of the earliest foreign plants noted to naturalize in New England. Perhaps introduced as an ornamental garden flower, the plant spreads to develop colonies in areas not regularly disturbed—such as pastures and orchards—as described by John Bartram, an American botanist in 1759. Common toadflax thrives in lean, gravelly, and compacted soils, slowly increasing in number through its creeping roots, similar to rhizomes. In addition, toadflax, or butter and eggs as it is colloquially known, is tolerant of road salt, which makes this delicate-looking plant a tough urban competitor. It is often found along the seams between sidewalks and fences in addition to other places ill-suited to most plants. *Linaria* is related to the snapdragon, clearly seen in the slender, pale yellow flowers with an orange throat that can be made to talk by squeezing the back. The clusters of flowers are found at the ends of stalks clothed in grey, needle-like, attractive leaves—so closely set together they appear whorled around the stem. Toadflax has a well-established history of medicinal uses in Europe including being a treatment for jaundice, edema, and liver problems. It's known to have powerful qualities as a diuretic or purgative.

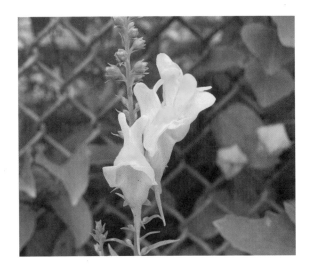

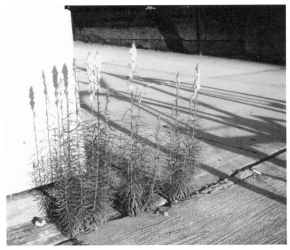

WILDLIFE HABITAT

MEDICINAL

EROSION PREVENTION

CONYZA CANADENSIS
Horseweed

SEED DISPERSAL
FLOWERING
LEAF GROWTH

J F M A M J J A S O N D

Horseweed is an early colonizer of sunny, open urban successional sites with gravel or bare ground. Emerging as a series of single spikes, the plant quickly forms large monocultures that move together as wind sets into motion the top-heavy plumes and evokes a romantic meadow-like effect despite the often rubble-strewn context. Over the course of one summer, *Conyza canadensis* seedlings will develop into a tapering spike, four to six feet tall. In late summer, the stem branches out from an inconspicuous basal rosette of leaves to carry an airy panicle of tiny white flowers. These flowers are often covered in a cloud of insects, providing food for small wasps, flies, and bees, and the occasional muskrat. The botanical name *Conyza*, derived from the Greek word for flea, speaks to its early use in deterring fleas from taking residence in bedding. Historically, it has been used to treat gout, menstrual cramps, and kidney stones. Horseweed contains a compound that can irritate one's nose and has been used intentionally by humans to induce sneezing as a means to relieve sinus pressure. The dried stems of horseweed are considered one of the best materials with which to make fire using the classic friction technique.

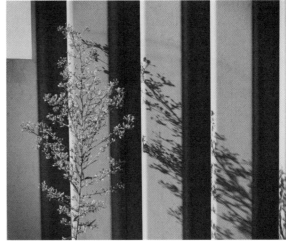

WILDLIFE HABITAT

MEDICINAL

EDIBLE

EROSION PREVENTION

ARTEMISIA VULGARIS
Mugwort

SEED DISPERSAL
FLOWERING
LEAF GROWTH

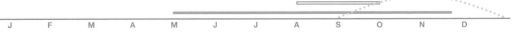

J F M A M J J A S O N D

In vacant lots, gardens, sidewalk cracks, and along the base of buildings, Mugwort can be found nearly everywhere in the city. If left unchecked, *Artemisia vulgaris* can form large monocultures, with a dense system of rhizomatous roots. It can populate new locations through its wind-dispersed seed, which it produces in great quantity, preferring alkaline soils rich with nitrogen. Mugwort grows to four feet and, due to the white, woolly undersides of leaves, looks silvery when the wind blows through a colony. The density of flower spikes produced in autumn can cause the entire plant to bend under the weight. The deeply lobed leaves of *Artemisia vulgaris* resemble the leaves of chrysanthemum with a similar strong, pungent fragrance. Also known as common wormwood, it has a long history of use in herbal medicine for a litany of ailments—from intestinal disorders to depression. In Europe, plants were thought to ward away evil spirits and protect people from fatigue, wild beasts, and sunstroke. *Artemisia* was used to season meat and to impart a bitter flavor to beer—resulting in its common name, mugwort. Leaves were dried and made into tea or smoked by sailors as an inexpensive alternative to tobacco.

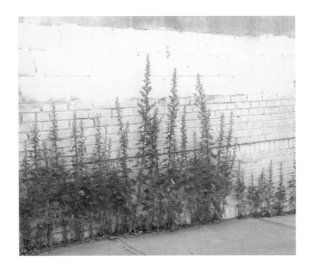

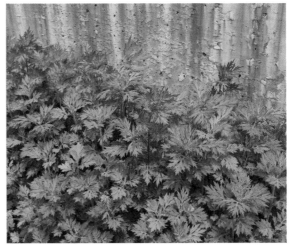

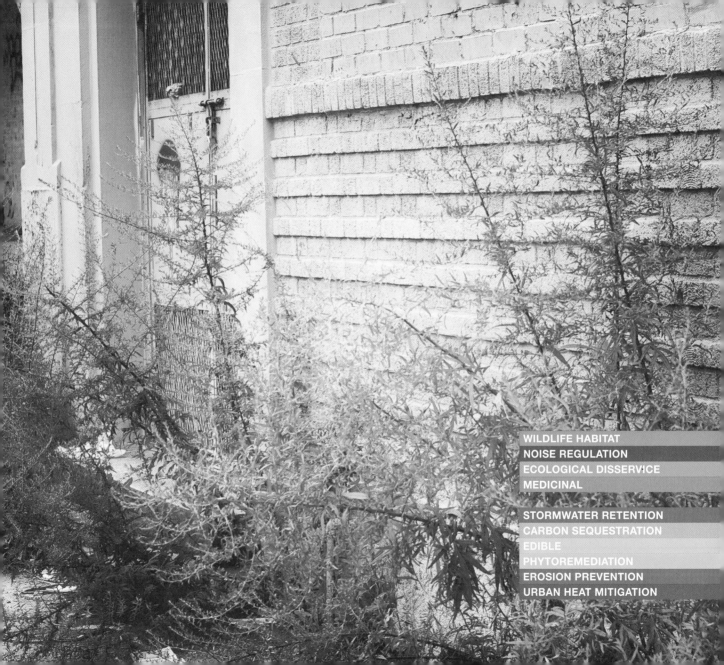

WILDLIFE HABITAT
NOISE REGULATION
ECOLOGICAL DISSERVICE
MEDICINAL

STORMWATER RETENTION
CARBON SEQUESTRATION
EDIBLE
PHYTOREMEDIATION
EROSION PREVENTION
URBAN HEAT MITIGATION

DATURA STRAMONIUM
Jimsonweed

SEED DISPERSAL
FLOWERING
LEAF GROWTH

| J | F | M | A | M | J | J | A | S | O | N | D |

Native to North America, this plant from the nightshade family favors fertile soils in warm, moist climates but can easily grow in dry, sandy places along the edge of beaches and in tree pits. Known as jimsonweed, stinkwort, devil's trumpet, or locoweed, the plant has been widely used around the world for its hallucinogenic properties. *Datura stramonium* is a highly toxic, foul-smelling herb that in one season can grow from a seed into a well-branched plant, nearly four feet tall. Its stems are a deep purple and its leaves resemble oak leaves in that they are deeply lobed. Fruits of the jimsonweed are hard egg-shaped pods covered in spikes. Large, pale purple trumpet flowers are produced in the height of summer and will continue to bloom through the first frost. All parts of the plant contain alkaloids that cause hallucinations in those ingesting them, and can easily result in overdose. In a 1676 account of this effect, British Soldiers sent to Jamestown, Virginia to suppress a rebellion were unknowingly given *Datura* with their dinner, rendering them useless in their official capacity. It has been used to treat asthma in India, and has long been a component of spiritual and sacred rituals of many cultures for the intense visions it produces.

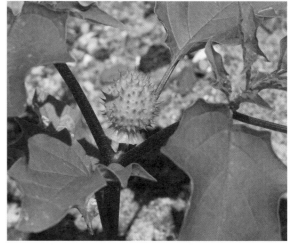

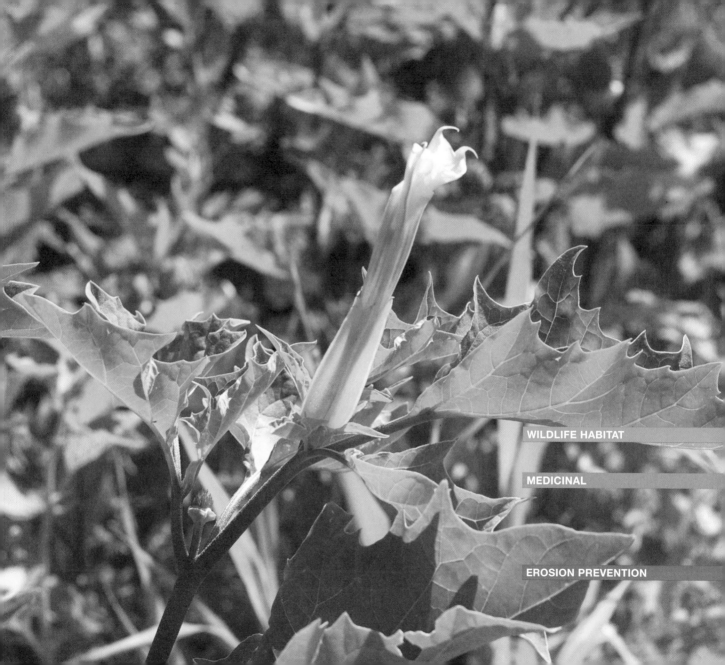

WILDLIFE HABITAT

MEDICINAL

EROSION PREVENTION

OENOTHERA BIENNIS
Evening Primrose

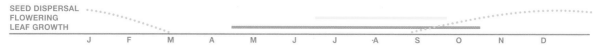

	J	F	M	A	M	J	J	A	S	O	N	D
SEED DISPERSAL												
FLOWERING												
LEAF GROWTH												

Oenothera biennis is typically found in dry open fields, vacant lots, along roadside and railroad embankments, in tree pits, and growing through small cracks. At home in disturbed sites, it is often considered a pest despite being a North American native. Evening primrose appears to stand tall and bright within its wild surroundings, with striking bright yellow lemon-scented flowers branching from a basal rosette. A biennial that blooms in late spring, the plant exhibits remarkable diurnal ephemeral qualities— closing its flowers for the day, only to open in the evening and through the night. The flowers develop into tall spikes of distinctive woody capsules upon maturity, which persist through the winter into the following season. The sweet inflorescence and nectar, edible roots and shoots, and nutritious seeds are attractive qualities to hummingbirds, moths, small mammals, and deer. It is most commonly known to humans for its medicinal applications, which include treatment of gastrointestinal disorders, asthma, and even obesity. Oil is extracted from the seeds and is commonly taken for relief from premenstrual pain. Leaves and flowers are used in many homeopathic remedies to reduce aches and to counteract flaws in complexion.

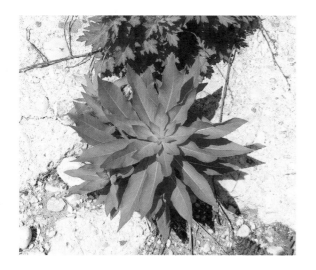

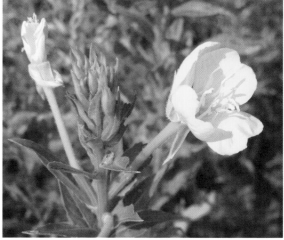

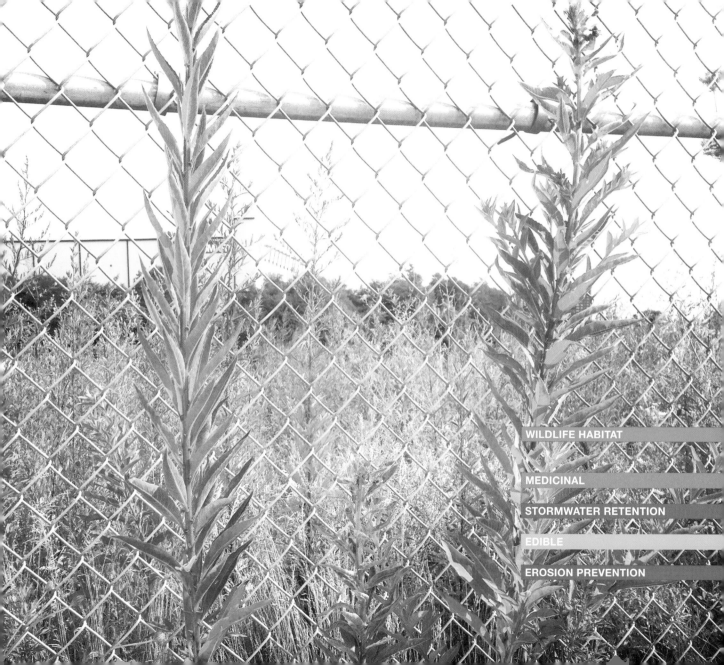

WILDLIFE HABITAT

MEDICINAL

STORMWATER RETENTION

EDIBLE

EROSION PREVENTION

CONEY ISLAND, BROOKLYN
40°34' N, 73°58' W

THURSDAY MORNING IN AUGUST, I'M OUT WITH A COUPLE OF FELLOW FUTURE GREENERS. IT'S QUIET AND THE WIND IS GENTLY BLOWING. YOU CAN FEEL THE TEMPERATURE DROP WHEN YOU ARE CLOSER TO THE WATER. THE SUN IS BRIGHT—MANY PHOTOS HAVE HEAVY SHADOW LINES AND LOOK OVEREXPOSED. THERE ARE LOTS OF URBAN MEADOWS AMIDST THE VACANT LOTS. CRABGRASS ROOTED INTO THE SAND THAT DRIFTED ONTO THE BOARDWALK.

WEATHER : SUNNY AND BRIGHT
DURATION : 02:20:17

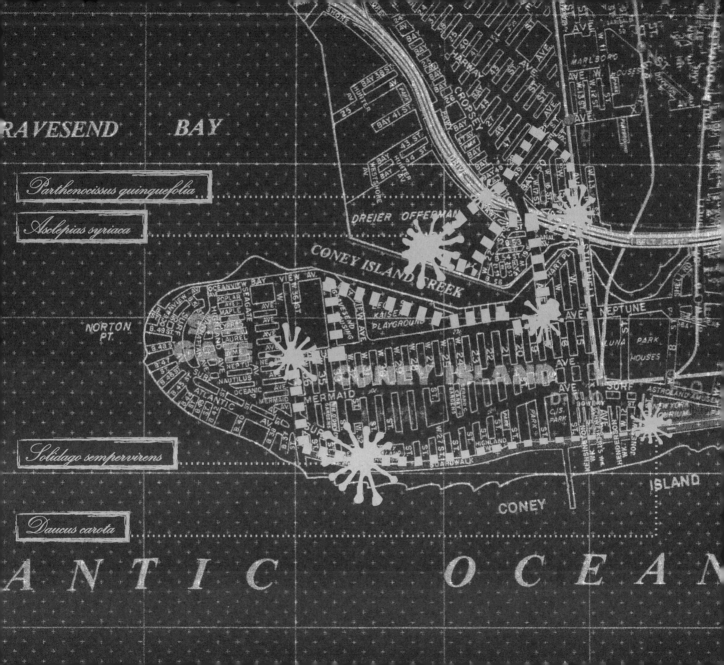

RAVESEND BAY

Parthenocissus quinquefolia

Asclepias syriaca

Solidago sempervirens

Daucus carota

NORTON PT.

DREIER OFFERMAN

CONEY ISLAND CREEK

CONEY ISLAND

NEPTUNE

LUNA PARK HOUSES

SURF

CONEY ISLAND

ATLANTIC OCEAN

WILDLIFE HABITAT
noun /ˈwaɪld·laɪf , ˈhæbɪtæt/

OUR PROLIFIC DEVELOPMENT OF URBAN AREAS HAS REDUCED EXTANT WILDLIFE HABITAT AND THEIR FORAGING GROUNDS. IN CONSIDERING HOW TO REINTRODUCE WILDLIFE HABITAT INTO OUR CITIES, ONE QUESTION IS WHETHER THE PATCHWORK ECOLOGY OF SMALL-SCALE GREEN INFRASTRUCTURE INTERVENTIONS CAN PROVIDE SUBSTANTIAL WILDLIFE HABITAT. MOST OF THESE SITES TEND TO BE INTIMATELY SIZED AND DISCONNECTED FROM ONE ANOTHER, AND YET WILD URBAN PLANTS MIGHT PROVIDE THE CONNECTIVE LINK BETWEEN THESE DISPARATE PATCHES. OFFERING FOOD AND SHELTER, MANY WILD URBAN PLANTS PROVIDE IMPORTANT VALUE TO BEES, INSECTS, BIRDS, AND SMALL MAMMALS. WILD URBAN PLANTS OFFER A VARIETY OF HABITATS FOR WILDLIFE—PROVIDING AERIAL ROOSTS IN WEED TREES, DARK, WOODY NESTING PLACES UNDER THE COVER OF VINES, AND PROTECTION BY CAMOUFLAGE AMIDST GRASSES AND FLOWERING PLANTS IN AN OPEN, URBAN MEADOW.

WILDLIFE
HABITAT

ASCLEPIAS SYRIACA
Common Milkweed

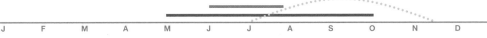

SEED DISPERSAL
FLOWERING
LEAF GROWTH

J F M A M J J A S O N D

Although farmers despise it as an invader of pastures and hayfields, *Asclepias syriaca* is one of the earliest recorded North American species in the 1635 work, *Canadensium Plantarum Historia*. In urban areas, the perennial can be found growing in vacant lots, along roadsides, and in open, urban meadows—often in dense patches formed by a network of underground rhizomes. Common milkweed can attain a height of nearly five feet during inflorescence. It produces large flower clusters composed of over one hundred individual pink flowers. The spherical umbels are extremely fragrant and are attractive to a host of bees, butterflies, moths, beetles, and bugs, but milkweed is most celebrated for its relationship with the Monarch butterfly. Monarchs only use the white underside of young, velvety *Ascelpias* leaves to lay their eggs. The chemicals secreted from the plant are absorbed by the larvae—whose sole source of food is milkweed foliage—and make the larvae, caterpillar, and the adult butterflies extremely distasteful to predators. The species is noted for its tear-shaped seed pods that open to reveal attractive flossy, wind-dispersed seeds, which can fly great distances and are often among the first colonizers of a successional meadow.

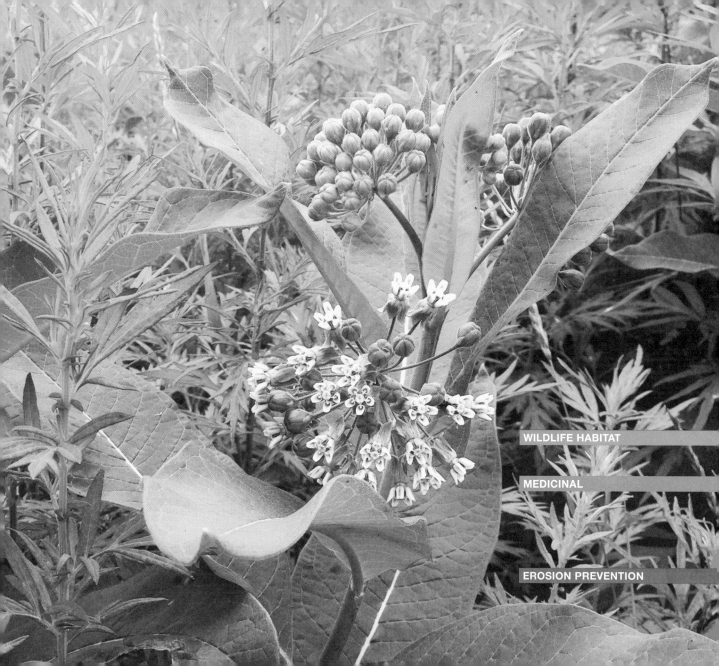

WILDLIFE HABITAT

MEDICINAL

EROSION PREVENTION

SETARIA VIRIDIS
Green Foxtail

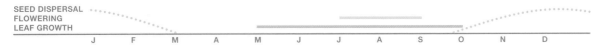

SEED DISPERSAL
FLOWERING
LEAF GROWTH

J F M A M J J A S O N D

The tail-like seed head of *Setaria viridis* can be seen nearly everywhere at the height of summer—it is one of the most ubiquitous members of the urban flora for its ability to flourish in highly disturbed areas. Introduced to North America as a forage grass in the early 1800s, green foxtail grows spontaneously along railroad tracks and highway medians, in vacant lots and neglected parks. Green foxtail rarely enters established natural areas, requiring the bare earth of disturbed environments to germinate. If conditions are amenable, *Setaria* can produce multiple generations of plants in one season. The plants develop very quickly, cycling through flowering and seed production early in the season, with the ability to spread through suitable habitat with ease. Small tufts of erect blades emerge in the spring. Soon thereafter, these annual plants shoot up slender flower stalks that terminate in a bottlebrush-like collection of bristled florets which nod under the weight of seeds. Many insects feed on the species, including grasshoppers, leaf beetles, aphids, and stinkbugs. Several species of upland and wetland birds eat the seeds and foliage, as do small mammals such as mice, squirrels, and domestic cattle—all of which are dispersal vectors.

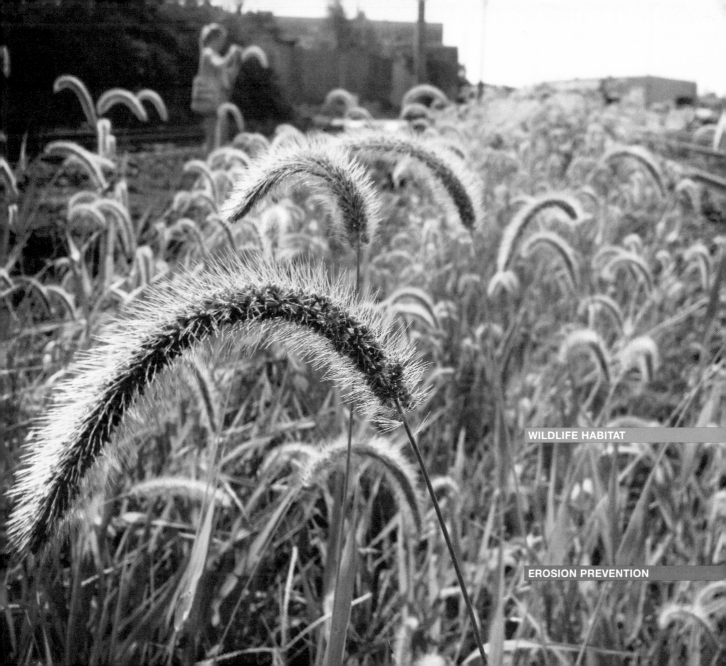

WILDLIFE HABITAT

EROSION PREVENTION

SOLANUM DULCAMARA
Bittersweet Nightshade

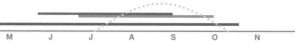

SEED DISPERSAL
FLOWERING / FRUIT
LEAF GROWTH

J	F	M	A	M	J	J	A	S	O	N	D

A perennial, rhizomatous vine, *Solanum dulcamara* can be seen twining over other plants, trailing along the ground, or growing erect, to a length of ten or more feet. The semi-woody plant can rise to great lengths each year, even if the stems have died or been cut to the ground the previous season. Bittersweet nightshade also has the ability to sucker, sending up new shoots at various points along the root system. *Solanum dulcamara* is highly adaptable, tolerant of compaction as well as periods of standing water. It can be found in dry sites as well as in riparian habitats. The dangerously enchanting flowers and fruit of the bittersweet nightshade make it an instantly recognizable member of the cosmopolitan flora. Attractive, small purple flowers, centered with a "beak" of yellow anthers are followed by shiny, bright red fruit—all parts of which are considered toxic to humans. Flowers and fruits occur together on the same plant throughout the summer. The fruits are dispersed by the numerous birds and mammals that eat them, including black bear, deer, raccoon, rabbits, and skunk. Its woody structure creates a dark and impenetrable shelter for small animals and its flower is a major food source for bumble bees.

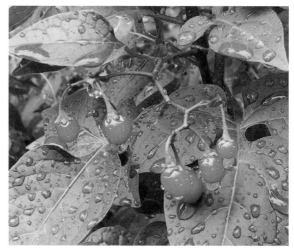

WILDLIFE HABITAT

MEDICINAL

STORMWATER RETENTION
CARBON SEQUESTRATION
EDIBLE

EROSION PREVENTION

ERIGERON ANNUUS
Annual Fleabane

SEED DISPERSAL
FLOWERING
LEAF GROWTH

| J | F | M | A | M | J | J | A | S | O | N | D |

One of a few native annual plants in the northeastern United States, the daisy fleabane can be found in large masses and often contributes to an aesthetically pleasing urban meadow. *Erigeron annuus* prefers sunny habitats, with a proclivity for dry lots, railroad tracks, and pavement edges as well as more rural habitats, such as pastures and vegetable gardens. Considered a pest to farmers, daisy fleabane can tolerate diverse types of soil, accounting for its success in urban environments and its ability to pioneer disturbed landscapes. This pretty annual of the Aster family is a distinctive, early blooming plant. Flower spikes rise to four feet from a basal rosette of foliage in June and produce successive generations of flower and seed until frost. Each flower has a small, yellow disc surrounded by a hundred narrow white petals. When drought strikes, the plants react by losing their basal foliage, which turns yellow before it falls off. The nectar and pollen of *Erigeron annuus* attract numerous species of long-tongued and short-tongued bees, wasps, flies, beetles, and bugs. Other mammalian herbivores have been spotted eating the foliage, flowers, and stems including deer, sheep, groundhogs, and rabbits.

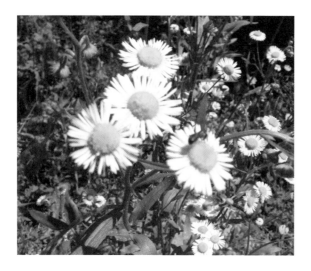

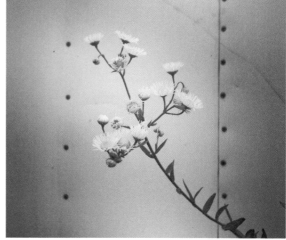

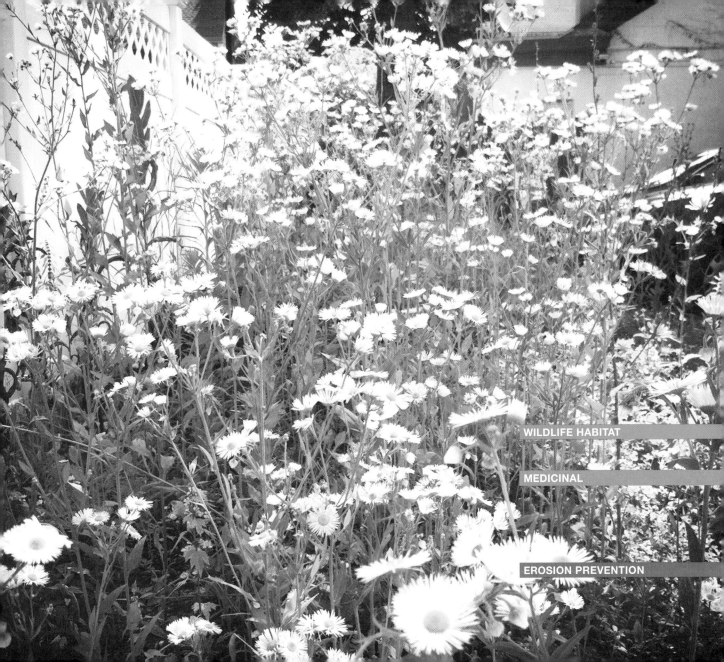

WILDLIFE HABITAT

MEDICINAL

EROSION PREVENTION

PARTHENOCISSUS QUINQUEFOLIA
Virginia Creeper

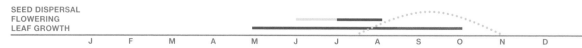

SEED DISPERSAL
FLOWERING
LEAF GROWTH

J F M A M J J A S O N D

This native creeper has become fairly commonplace in urban vacant lots and is evocative of a romanticism of ivy-covered buildings. *Parthenocissus quinquefolia* is a remarkable climber found growing on sunny walls, semi-shady edges, woodlands, telephone poles, and unmown areas. Growing up to fifteen feet in a season after establishment, the vine can reach one hundred feet in length at maturity. With incredible adhesive pads, the virginia creeper has the ability to climb most surfaces and cover large areas quickly without damaging the surface. Five coarsely-toothed radial leaflets are dotted with small clusters of greenish-white flowers in late spring, purplish-black berries in the summer and in the autumn, the leaflets turn hues of deep scarlet, maroon, and orange. *Parthenocissus quinquefolia* is a very effective habitat provider and attracts a host of wildlife. Its thick foliage and berries are eaten by several caterpillars, beetles, birds, and mammals such as skunks, chipmunks, squirrels, deer, and foxes. Several species of Sphinx moths lay their larvae exclusively in the plant. Many vines have a tendency to smother, and virginia creeper is no different, often considered a nuisance for its profusion.

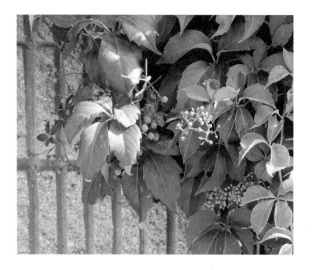

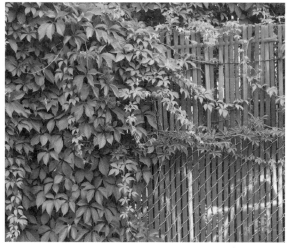

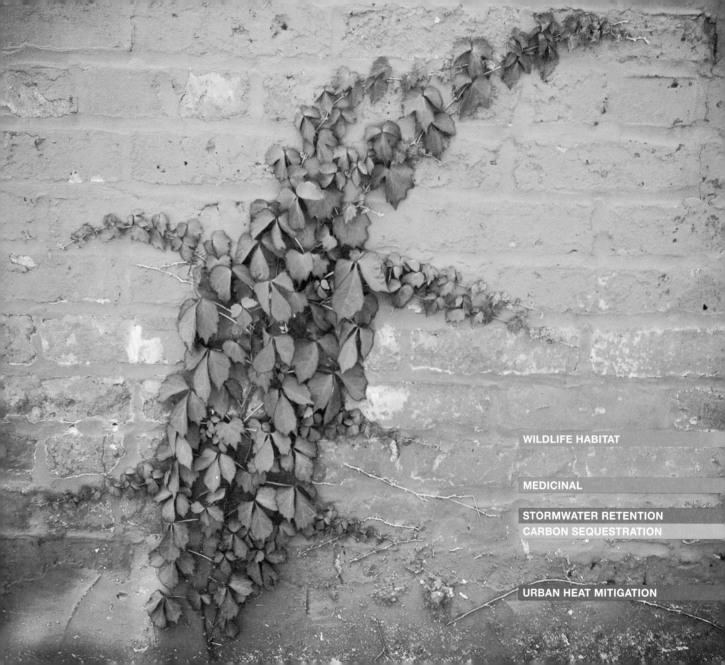

WILDLIFE HABITAT

MEDICINAL

STORMWATER RETENTION
CARBON SEQUESTRATION

URBAN HEAT MITIGATION

SOLIDAGO SEMPERVIRENS
Seaside Goldenrod

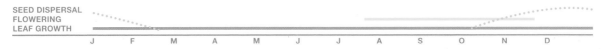

SEED DISPERSAL
FLOWERING
LEAF GROWTH

J F M A M J J A S O N D

Naturally occurring in dunes along the east coast of North America from Mexico to Newfoundland, *Solidago sempervirens* is well adapted to harsh, urban conditions and tolerant of lean soils, drought, wind, exposure, and salt. Plants can sprout from such unlikely places as the base of street signs, with only a sliver of exposed soil. Heavy shade proves to be one of the few environmental conditions that impair the growth of this goldenrod. Generally two to three feet tall, seaside goldenrod may reach a height of six feet in richer soils and full sun. The tall inflorescence is held above a basal rosette of waxy, evergreen leaves. This goldenrod's somewhat succulent vegetation contributes to its ability to thrive where other plants cannot. *Solidago sempervirens* does not spread by rhizome as many other goldenrods do, but produces off-shoots at the crown of mature perennial plants, slowly forming large masses over time. It readily spreads via its wind-dispersed seeds, which number in the hundreds. Seaside Goldenrod bears the iconic, golden flower panicles of all goldenrods, from late July to November. The flowers are a major food source for the migrating monarch butterfly as well as a countless array of wildlife.

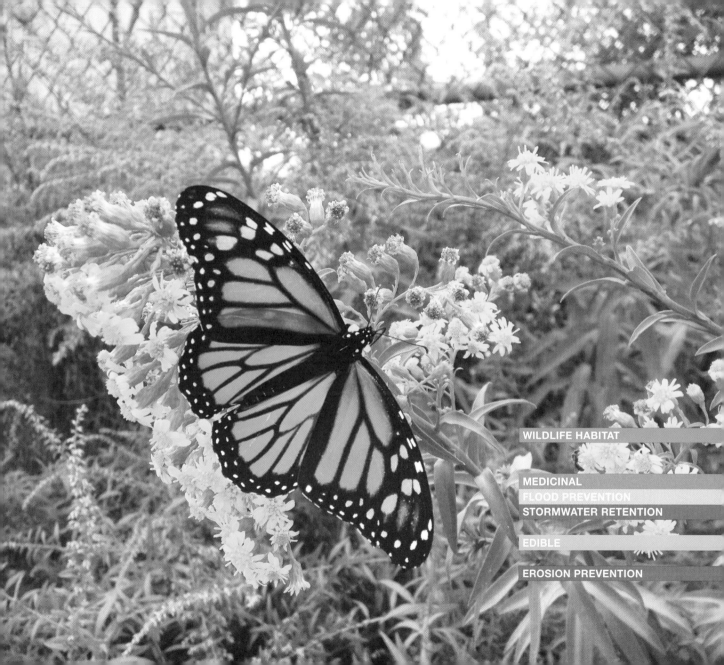

WILDLIFE HABITAT

MEDICINAL
FLOOD PREVENTION
STORMWATER RETENTION

EDIBLE

EROSION PREVENTION

DAUCUS CAROTA
Queen Anne's Lace

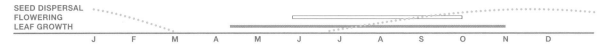

SEED DISPERSAL
FLOWERING
LEAF GROWTH

| J | F | M | A | M | J | J | A | S | O | N | D |

Queen Anne's lace needs little introduction as one of the most loved plants of the urban flora, long since naturalized in North America. It draws no distinction between urban and rural conditions, growing wherever soil disturbance allows. *Daucus carota* is a biennial flourishing in a range of habitats, but can often be seen along roads, unmown areas, and small openings in pavement. Plants can grow to a height of two to four feet, with creamy white flowers clustered in a flat, compound umbel often with a solitary flower of dark purple in the center. Wild carrot is a prolific bloomer, flowering from June into autumn. As seeds mature the flower stalks bend inward, forming a concave "bird's nest." The wild carrot is the progenitor of the cultivated carrot, which can be seen in the flower and taproot—while lacking in the sweet flavor. *Daucus carota* also provides food to a wide variety of wildlife. Flowers provide nectar and pollen to pollinators and many insects and caterpillars feed on the stem, foliage, and sugary tap root of the plant. Large birds, mice, rabbits, and deer are also known to browse on the plant in all of its life forms. Seeds of wild carrot have been used throughout human history as a means to reduce female fertility.

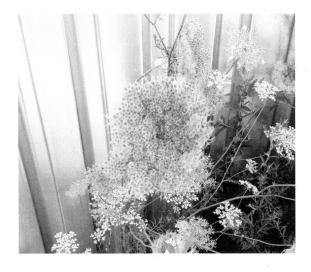

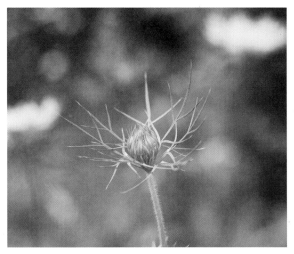

WILDLIFE HABITAT

MEDICINAL

EDIBLE

EROSION PREVENTION

LONG ISLAND CITY, QUEENS
40°44' N, 73°56' W

QUIET SUNDAY MORNING IN LATE SPRING. I START EARLY. THERE'S STILL A LITTLE DEW ON THE GRASSES. I'M WALKING SOLO EXCEPT FOR THE FEW TOURISTS LEAVING THEIR HOTELS TO HEAD INTO THE CITY. THE WEEDS ARE REALLY ALIVE RIGHT NOW. WEEK TO WEEK YOU SEE SUCH SUBSTANTIAL GROWTH. THIS PART OF QUEENS HAS LOTS OF NEGLECTED POCKETS. THE SPACES IN BETWEEN THE AUTO SHOPS AND BUILDING SUPPLY WAREHOUSES PROVIDE SLIVERS FOR WEED TREES TO EMERGE.

WEATHER : COOL AND SUNNY
DURATION : 01:52:34

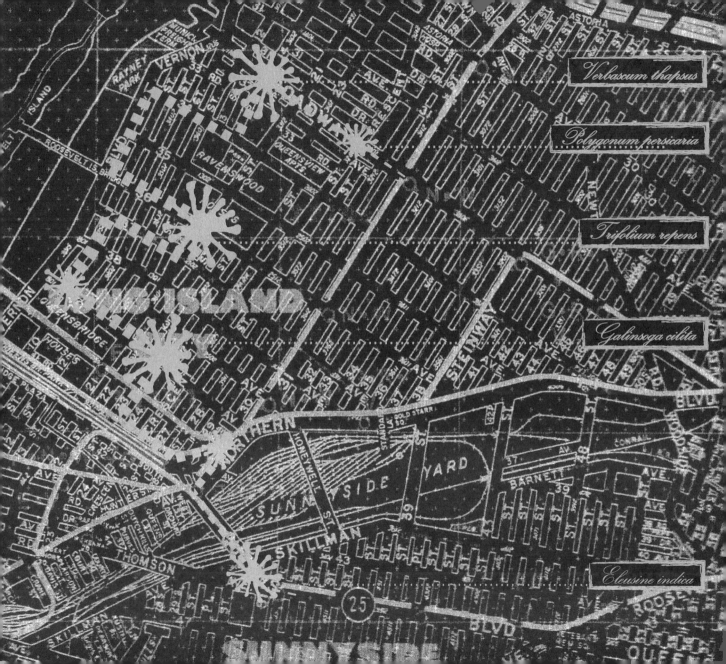

Verbascum thapsus

Polygonum persicaria

Trifolium repens

Galinsoga cilita

Eleusine indica

STORMWATER RETENTION
noun /stôrm,wô'tər', rɪˈtenʃn/

HIGHER RATIOS OF IMPERMEABLE SURFACES IN URBAN AREAS EXPONENTIALLY INCREASE THE AMOUNT OF WATER POURING INTO STORM DRAINS. IN NEW YORK CITY, WHICH HAS A COMBINED STORMWATER AND SEWER SYSTEM, MANY RAINFALLS THROUGHOUT THE YEAR OVERWHELM THE SYSTEM'S STORMWATER CAPACITY, RESULTING IN RAW SEWAGE BEING RELEASED INTO LOCAL WATERWAYS. ADDITIONALLY, RUNOFF CARRIES A RANGE OF SURFACE POLLUTANTS INTO OUR WATERWAYS, INCLUDING SEDIMENT, OIL, AND HEAVY METALS. MANY WILD URBAN PLANTS HAVE THE ABILITY TO GROW IN GRAVEL LOTS AND ABANDONED PARKING LOTS WHICH CAN INCREASE THE LOCAL WATERSHEDS CAPACITY TO HANDLE SIGNIFICANT RAINFALL IN THOSE AREAS. IN PARTICULAR, LOW-GROWING, PROSTRATE, AND MAT-FORMING PLANTS, WHICH INHABIT THE STREET EDGES AND SIDEWALKS, ARE ESPECIALLY EFFECTIVE IN LIMITING THE FIRST FLUSH OF A RAINFALL, WHICH CAN LAST ONLY A MINUTE OR TWO BUT CAN HOLD A SUBSTANTIAL AMOUNT OF THE RAINFALL IN AN EVENT. SLOW IT DOWN, SPREAD IT OUT, AND LET IT SOAK IN.

STORMWATER
RETENTION

PHRAGMITES AUSTRALIS
Common Reed

SEED DISPERSAL
FLOWERING
LEAF GROWTH

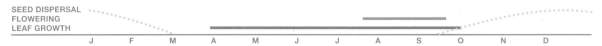

J F M A M J J A S O N D

Phragmites australis typifies the spontaneous urban flora better than any plant, with the exception of *Ailanthus*. Vilified for ruining pristine native habitats, *Phragmites* has the ability to colonize anthropogenic-altered sites, tolerating a range of pollution and salinity levels that both fresh water and strictly salt water plants find challenging. It does not appear to discriminate about habitat and is one of the most widely distributed flowering plants, present on all continents but Antarctica, in all manner of soils. Once established, common reed can form large monocultures, spreading through a dense network of thick rhizomes that can grow to seventy feet in length. It can also spread via seeds, produced in great quantities, which are both wind and water dispersed. Flower plumes are clustered on the top of fifteen-foot-tall stalks, with a purple sheen that changes to brown in the autumn and over the course of winter. The sheer productivity of the plant has been harnessed to absorb pollutants, from heavy metals to water impurities. Although fields of *Phragmites* stabilize soil and provide habitat for many birds and animals, large monocultures adversely affect critical sedimentation rates, bird and fish habitat, and intricate food webs.

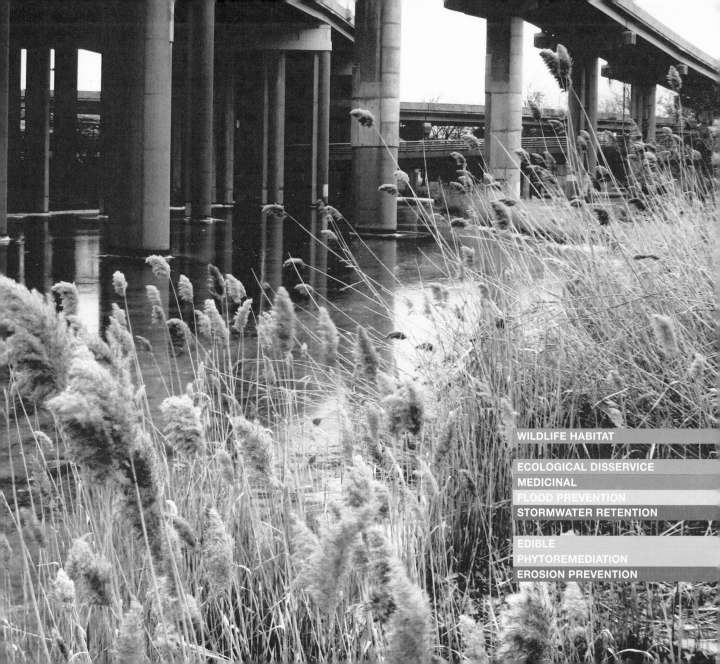

WILDLIFE HABITAT

ECOLOGICAL DISSERVICE
MEDICINAL
FLOOD PREVENTION
STORMWATER RETENTION

EDIBLE
PHYTOREMEDIATION
EROSION PREVENTION

POLYGONUM AVICULARE
Prostrate Knotweed

SEED DISPERSAL
FLOWERING
LEAF GROWTH

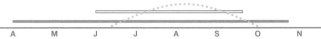

| J | F | M | A | M | J | J | A | S | O | N | D |

From its origins in the Eurasian steppe, prostrate knotweed has claimed harsh, urban habitats as its own. Tolerant of nutrient-poor soils, compaction, and pollution, it takes hold where other plants have difficulty. *Polygonum aviculare* is found growing along the pathways and desire lines of public parks and athletic fields. Prostrate knotweed flourishes in tight spots by developing a taproot which allows it to support a lush mat of foliage that radiates from the crown to a considerable width. Often found in sidewalk seams, prostrate knotweed catches sediment and small debris, slowing the flow of rainwater into catchment basins. Small oval leaves run along the wiry stems that have swollen "knees" at each leaf node. Its pale pink flowers are relatively inconspicuous, partially obscured by the foliage. *Polygonum aviculare* is an annual weed that produces flowers from June to October, with an equally long seeding period. The tiny, hard seeds can persist on a site for years before conditions allow germination. In times of famine, the seeds have been gathered to be ground into flour for human consumption, which is quite a feat considering the size. Seeds of the prostrate knotweed have also been used to flavor tea and soup in Asia.

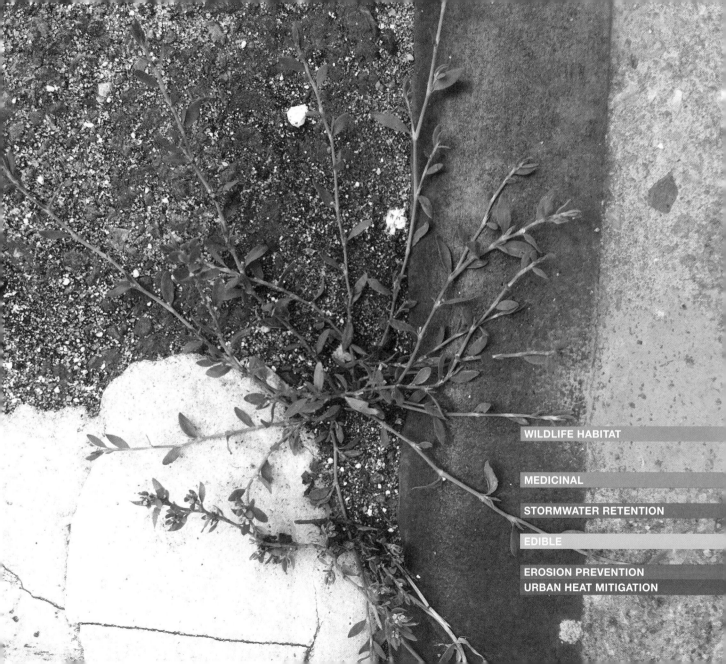

WILDLIFE HABITAT

MEDICINAL

STORMWATER RETENTION

EDIBLE

EROSION PREVENTION
URBAN HEAT MITIGATION

ELEUSINE INDICA
Goose Grass

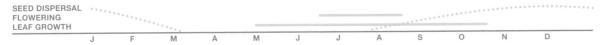

SEED DISPERSAL											
FLOWERING											
LEAF GROWTH											
J	F	M	A	M	J	J	A	S	O	N	D

Eleusine indica thrives in the disturbed soils of cities and can be found growing out of cracks in asphalt, along roads, in parking lots, or in the relatively lush habitat that tree pits and park lawns provide. It is tolerant of drought, compaction, and due to its prostrate habit even endures close mowing. Its ability to grow within the thin seams of the streetscape makes it a valuable stormwater management contributor. The entire plant dies after the first, hard frost, but the dried seed heads remain through much of winter. Light-colored, nearly silver leaf sheaths are prominently displayed in the center of the plant's flat rosette and midsummer flowers are found in finger-like clusters, radiating from a central point. The flowers are much thicker and coarser overall than other types of crabgrass. Two to six spikelets form the terminal inflorescence, composed of coarse, flat culms that produce a lot of seed over the course of one season. Goosegrass may have acquired its name from the resemblance of the flower spikes to the splayed pad of a goosefoot. The grass is eaten by cattle and horses and the seeds remain viable throughout digestion. It has been cited as a food of famine as the seeds are edible, but the yield is so low it is more the food of desperation.

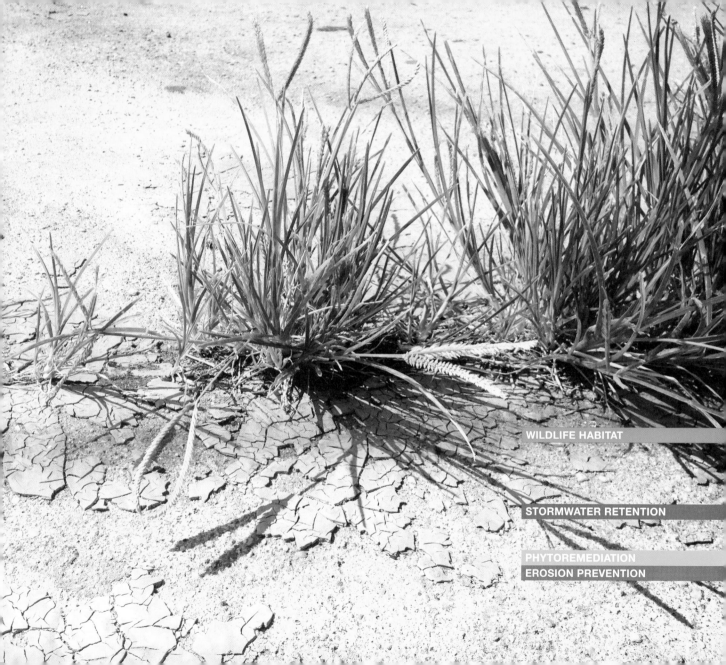

WILDLIFE HABITAT

STORMWATER RETENTION

PHYTOREMEDIATION
EROSION PREVENTION

TRIFOLIUM REPENS
White Clover

SEED DISPERSAL
FLOWERING
LEAF GROWTH

J F M A M J J A S O N D

Trifolium repens is a short, mat-forming perennial that originated in Europe and has become one of the most widely distributed legumes in the world. Clover is found in a variety of site conditions especially along roadways, vacant lots, urban meadows, and even on stone walls. It often remains green during a drought when surrounding plants go dormant—a testament to its tenacity. It spreads rapidly along the ground by its creeping stems and infiltrates even the purest of lawns, tolerating regular mowing. Its prostrate habit makes it effective as a roadside collector of stormwater runoff. The dark green leaves are smooth with a long, lightly haired stems and three rounded leaflets that typically droop at night. Every once in a while, plants will sport four-leaflets, considered good luck to whomever finds them. Terminal clusters of small white flowers form small spheres that appear in early spring and offer an important nectar source for pollinating insects. A sweet herb tea can be made from its dried flowers, and it has been used as a medicine for fevers and coughs by Native Americans. Clover is often planted for its ability to enrich the soil with nitrogen, which it does through a symbiotic relationship with bacterium in root nodules.

WILDLIFE HABITAT

MEDICINAL

STORMWATER RETENTION

EDIBLE
PHYTOREMEDIATION
EROSION PREVENTION

POLYGONUM PERSICARIA
Spotted Ladysthumb

SEED DISPERSAL												
FLOWERING												
LEAF GROWTH												
J	F	M	A	M	J	J	A	S	O	N	D	

Ladysthumb is quite an ornamental annual plant, exhibiting its relationship to the showy *bistorts* and *persicarias* intentionally grown for their flowers. Long since naturalized in North America from origins in Eurasia, *Polygonum persicaria* finds its way into garden plots, filling the bare ground between cultivated selections. Often in a small colony, it's found growing along the length of a street between the granite curb and concrete sidewalk making it a contributor in the reduction of the first flush of stormwater flow. Plants can grow to two feet tall, but have a tendency to flop over, scrambling along the ground,

bending at its characteristic swollen stem nodes. Leaves are often marked with a dark chevron, also found on other *Polygonums*. The diminutive but prolific pink spikes of flowers range in color from light pink to magenta. Individual flowers are so small they appear to be apetalous, but upon closer inspection bear five small petals. Bloom initiates in the heat of July, continuing through September. The long flowering period results in the production of copious seed, 800 to 1500 per plant, ensuring future generations of seedlings. The tiny black seeds are dispersed when animals or wind move stalks, shaking the seeds free.

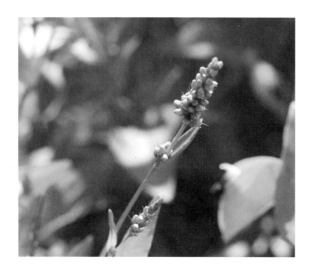
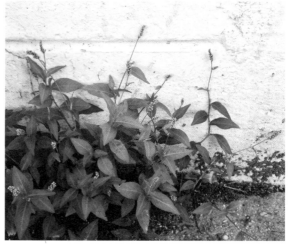

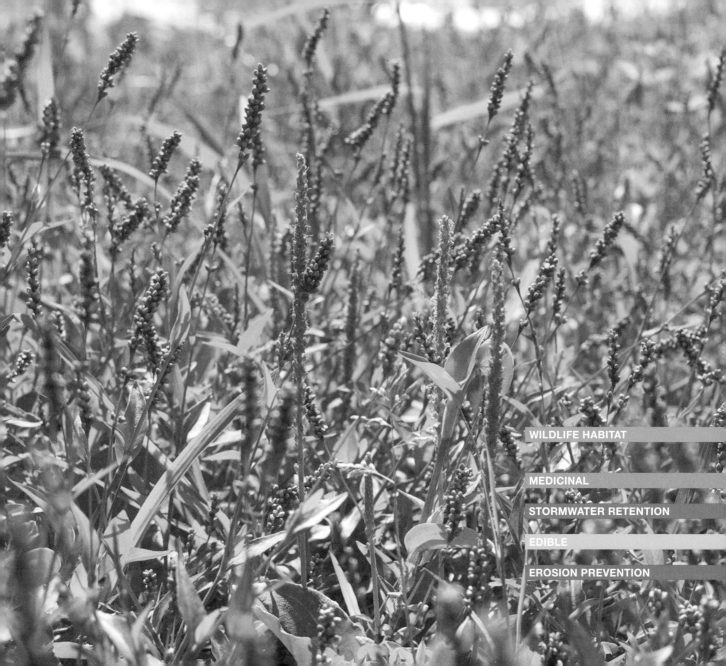

WILDLIFE HABITAT

MEDICINAL

STORMWATER RETENTION

EDIBLE

EROSION PREVENTION

VERBASCUM THAPSUS
Common Mullein

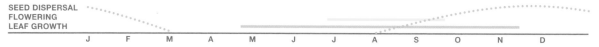

	J	F	M	A	M	J	J	A	S	O	N	D

SEED DISPERSAL
FLOWERING
LEAF GROWTH

Verbascum thapsus is a highly adaptable biennial that has naturalized across North America from origins in Eurasia. Mullein is tolerant of most growing conditions provided there is open ground for germination and full sun. In cities, common mullein can thrive in challenging sites, even growing from cracks in the pavement. This resiliency is due in part to its thick, fleshy taproot that stabilizes the plant while absorbing moisture and nutrients at great depths. Its low growth mitigates the flow of rain water, catching sediment and small debris headed for storm sewers. The distinctive rosette of fuzzy foliage emerges in the spring, and its tall flower spikes can be seen in late summer, rising from asphalt everywhere. Each small yellow flower lasts for a single day, but the succession of bloom from bottom to top occurs over the span of two months or more, with hundreds of individual blossoms. Thousands of seeds shake out of the dry capsules as the stalk sways in the wind or is moved by the force of birds that roost on the tip. Seeds are not broadcast far from the parent and plants are often seen in small colonies. Its soft, fuzzy leaves are used in hummingbird nests and also persist into late autumn, providing insulation for insects.

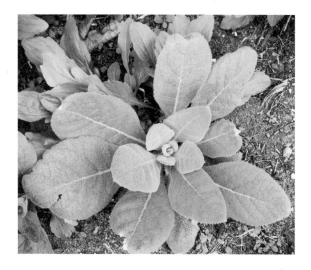

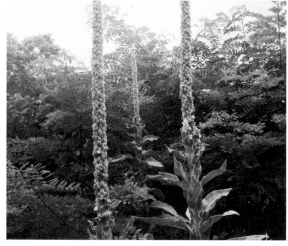

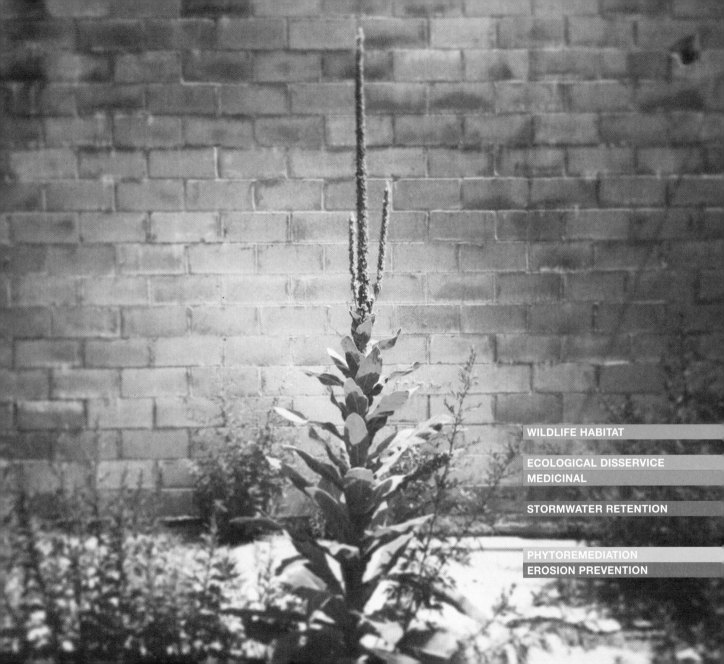

WILDLIFE HABITAT

ECOLOGICAL DISSERVICE
MEDICINAL

STORMWATER RETENTION

PHYTOREMEDIATION
EROSION PREVENTION

GALINSOGA CILIATA
Shaggy Soldier

SEED DISPERSAL
FLOWERING
LEAF GROWTH

J F M A M J J A S O N D

Galinsoga ciliata prefers sunny locations and fertile soils, but can be found in any number of typical urban sites, including vacant lots, rubble piles, and gardens where disturbance ensures germination. Hailing from Central America, shaggy soldier requires heat to sprout, which speaks to its common occurrence along walls and in pavements—places where temperatures are heightened. Upon first encounter, *Galinsoga's* small stature, soft hairs, and reduced flowers project the illusion of a modest plant, tucked into sidewalk cracks and crevices. However, since its introduction to the eastern United States in the early 20th century, it has increased exponentially, with approximately three generations of seed being produced in one growing season. The entire growth cycle of this annual plant can be completed in three to four weeks, contributing to one of its common names, quick weed. Seeds are wind-dispersed by means of a papery sail, but can also be moved around by human and animal vectors. The leaves are known to be quite tasty, especially as a cooked green. The young plant is eaten as a vegetable and dried for use as a seasoning in South America, Southeast Asia, and Africa.

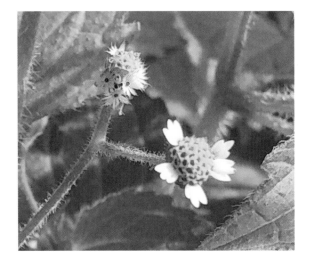

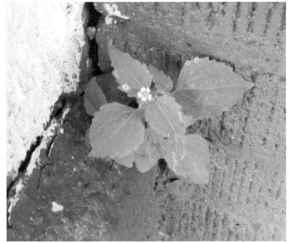

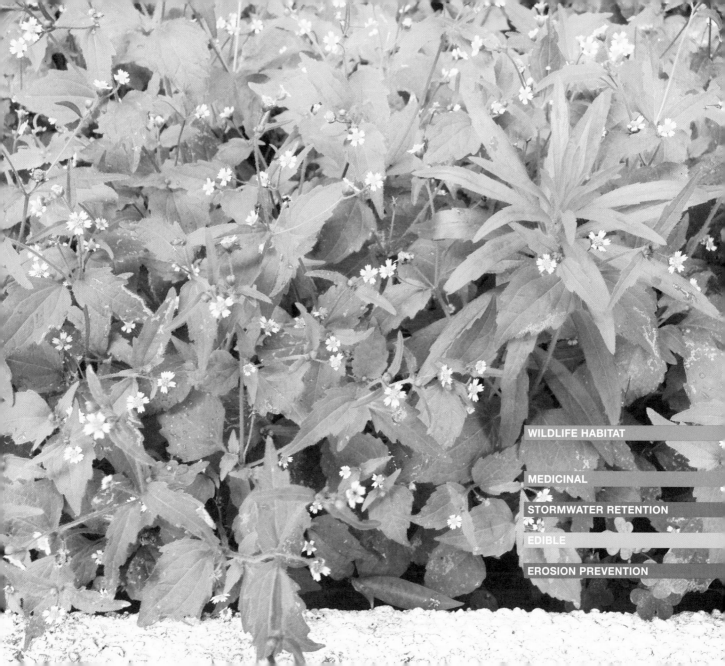

WILDLIFE HABITAT

MEDICINAL

STORMWATER RETENTION

EDIBLE

EROSION PREVENTION

NORTH BROOKLYN, NYC
40°43' N, 73°56' W

EARLY FRIDAY EVENING IN SUMMER. THE SKY IS CLEAR. WALKING WITH A FEW FRIENDS, THE CITY IS BUSTLING. EARLY ON WE STOP INTO A BAR TO REFUEL. AS WE LEAVE BILLYBURG, THINGS QUIET DOWN AND WE'RE ABLE TO GET TO A FRINGE. LOTS OF CHAINLINK FENCES AND PARKING LOTS. THE TREATMENT PLANT LOOMS IN THE BACKGROUND LIKE A MACHINE IN THE LANDSCAPE.

WEATHER : WARM AND CLEAR
DURATION : 03:08:23

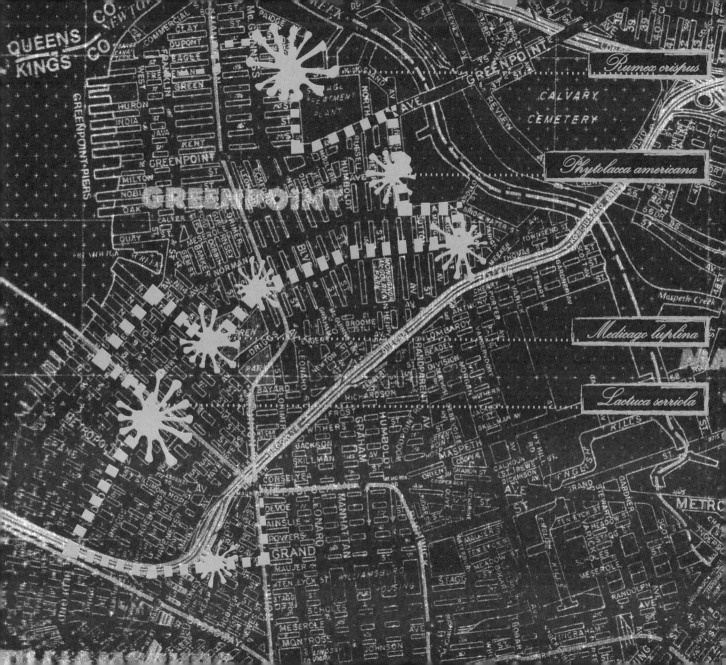

PHYTOREMEDIATION
noun /'fī'tō-rĭ-mē'dē-ā'shən/

MANY URBAN, POST-INDUSTRIAL SITES CONTAIN CONTAMINATED SOIL THAT IS EXPENSIVE TO REMOVE AND DIFFICULT TO REMEDIATE. SPONTANEOUS URBAN PLANTS ARE ADAPTED TO FLOURISH ON TOUGH SITES AND CAN ASSIST IN MITIGATING THE CONCENTRATIONS OF POLLUTANTS IN A GIVEN AREA. PLANTS CAN STABILIZE SITES WITH THEIR ROOT SYSTEMS, PREVENTING SOIL LOSS AND THE FLOW OF POLLUTANTS INTO WATERWAYS. MANY VIGOROUS PLANT SPECIES, CALLED HYPERACCUMULATORS, ARE ABLE TO UPTAKE HEAVY METALS FROM THE SOIL, BIND THEM IN THEIR CELL TISSUE, AND TRANSUBSTANTIATE THEM INTO LESS HARMFUL PHYSICAL STATES. SPECIFIC TYPES OF PHYTOREMEDIATION INCLUDE PHYTOSTABILIZATION, RHIZODEGRADATION, METABOLIZATION, AND PHYTOEXTRACTION.

PHYTOREMEDIATION

PHYTOLACCA AMERICANA
Pokeweed

SEED DISPERSAL
FLOWERING / FRUIT
LEAF GROWTH

| J | F | M | A | M | J | J | A | S | O | N | D |

Phytolacca americana celebrates the seasons in flare, with colorful drama. Pokeweed is a beautiful, shrub-like herbaceous plant native to eastern North America. It has a fondness for disturbance and is readily adaptable to a variety of site conditions, especially in rich gravelly soils and around abandoned lots and fields—wherever birds have dropped the seeds. Its smooth, round green stems change to a gleaming magenta as autumn approaches and racemes of white flowers in the spring develop seeds that transition into dark purple, glossy berries. In the winter, the plant dies back completely to its large taproot, from which it will resprout the following spring. It is frequented by bees that seek its nectar, but its berries are especially popular with songbirds such as the Eastern Bluebird, Mourning Dove, Robin, Starling, and several others. Most botanists consider all parts of the plant to be highly toxic, but young leaves have been picked and boiled as an asparagus substitute, known colloquially as poke salad. The dark berries are used in the preparation of a magenta ink, which fades to brown with age. Studies have revealed that pokeweed has the capacity to hyperaccumulate toxins such as cadmium and manganese.

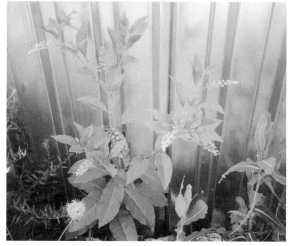

WILDLIFE HABITAT

MEDICINAL

EDIBLE
PHYTOREMEDIATION
EROSION PREVENTION

MEDICAGO LUPULINA
Black Medic

SEED DISPERSAL
FLOWERING / FRUIT
LEAF GROWTH

J F M A M J J A S O N D

Medicago lupulina is an old-world plant found on limestone outcrops and coastal sand dunes. Naturalized across North America from its use as a forage crop for livestock, in the urban environment black medic is most often found along roadsides and compacted walkways. Plants are spread only by seed, which can remain dormant for years until conditions are conducive for germination. It is relatively aggressive despite its diminutive habit and cute little yellow flowers, tolerating the shade produced by taller, herbaceous vegetation. Individual flowers are found in dense clusters along trailing stems produced from early May through September. Small clusters of black seed pods follow the blooms, while new flowers continue to be produced further along stems. Leaflets occur in threes and the plant resembles clover in most regards, except for a pointy beak on the tip of each leaflet. Black medic, like other legumes, increases the fertility of the soils it inhabits. *Medicago lupulina* can fix atmospheric nitrogen into a useable form through a symbiotic relationship with bacterium in the root zone. It has also shown a capacity to uptake heavy metals through its root system and could be used in conditions where phytostabilization is appropriate.

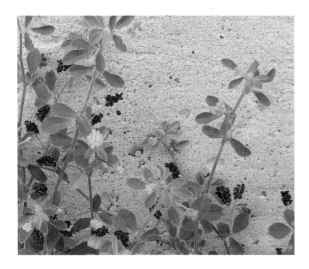

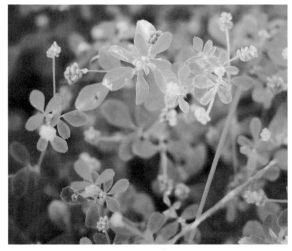

WILDLIFE HABITAT

STORMWATER RETENTION

PHYTOREMEDIATION
EROSION PREVENTION

POLYGONUM CUSPIDATUM
Japanese Knotweed

SEED DISPERSAL
FLOWERING
LEAF GROWTH

J F M A M J J A S O N D

Originally introduced to the United States as an ornamental plant, japanese knotweed can now be found nearly everywhere in the city. Tolerant of most habitat conditions, it can colonize riparian sites as well as cracks in asphalt. The plant can negatively impact extant native plant and faunal communities, but in urban conditions, *Polygonum cuspidatum* is being evaluated for its effectiveness as an accumulator of heavy metals, such as lead, copper, and arsenic. Bamboo-like stems can reach a height of ten feet each growing season, emerging from the ground anew after winter dormancy. White flowers form panicles along the stalks at each leaf axis and in terminal clusters. Each flower stalk can produce upwards of 150,000 seeds, dispersed by wind, water, and wildlife. *Polygonum cuspidatum* has an uncanny ability to reproduce itself, whether by seed or its dense network of thick rhizomes that are up to three inches in diameter, any piece of which can form an entirely new plant. Japanese knotweed is also well known to urban foragers, who eat the young tender shoots, similar to asparagus, after they have been boiled. Roots contain an antioxidant compound called resveratrol which is being explored for its anti-aging properties.

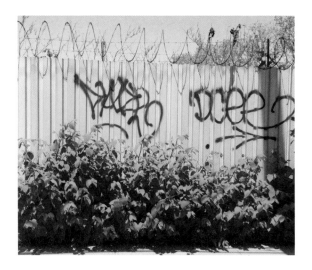

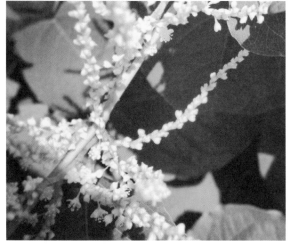

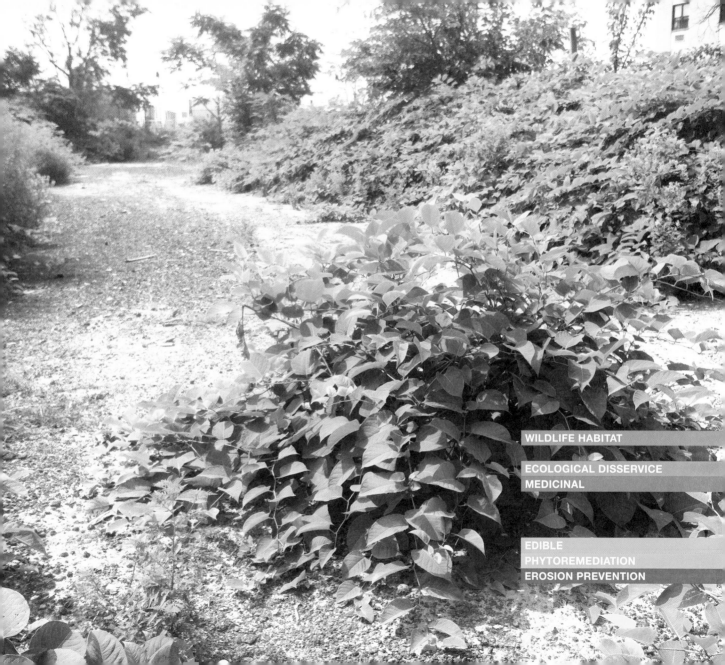

WILDLIFE HABITAT

ECOLOGICAL DISSERVICE
MEDICINAL

EDIBLE
PHYTOREMEDIATION
EROSION PREVENTION

TRIFOLIUM PRATENSE
Red Clover

SEED DISPERSAL
FLOWERING
LEAF GROWTH

| J | F | M | A | M | J | J | A | S | O | N | D |

Red Clover is such a commonly occurring plant that one could easily assume it to be a native. Initially introduced to North America as a component of forage crops, *Trifolium pratense* is tolerant of many habitats and has long since naturalized fields, roadsides, and vacant lots. Attractive clusters of small, individual flowers form the familiar mauve blooms of red clover. Easily identifiable, its leaflets are in threes and are covered with small hairs, displaying a white V on each blade. Red clover blooms from June to August, at which time it is visited by bees, moths, and butterflies. Although not as prolific as white clover, red clover can be used as livestock forage and as a bee plant in honey production. The entire plant is much larger than the more diminutive white clover, growing to a height of eighteen to twenty-four inches. As a perennial, the plant expends more energy into root development than simply seed production. The tough, expansive root system, with both taproot and rhizomes, enables the red clover to withstand the fluctuations of weather to persist and spread. Clover has the ability to increase its localized soil fertility through the presence of nitrogen-fixing nodules on its roots, and has long been used as a cover crop in agriculture.

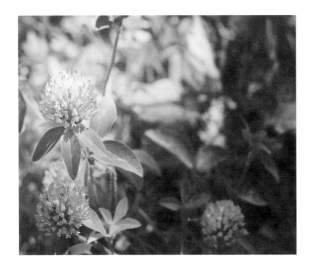

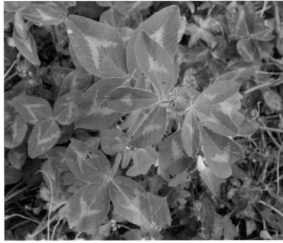

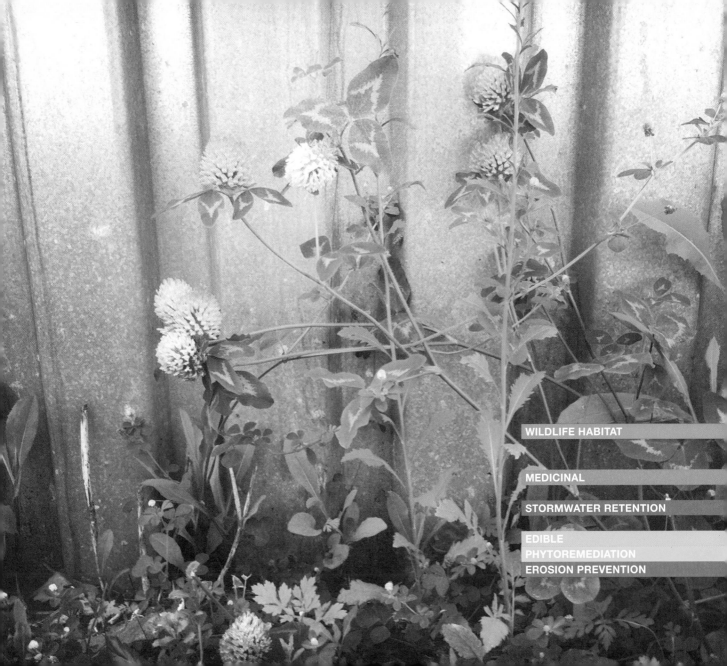

WILDLIFE HABITAT

MEDICINAL

STORMWATER RETENTION

EDIBLE
PHYTOREMEDIATION
EROSION PREVENTION

COMMELINA COMMUNIS
Asiatic Dayflower

SEED DISPERSAL
FLOWERING
LEAF GROWTH

| J | F | M | A | M | J | J | A | S | O | N | D |

Found along the margins of freshwater wetlands, ponds, and in parks and gardens, asiatic dayflower is disturbance-adapted and a first colonizer of bare ground. It is often spotted in relatively shady, damp places, as opposed to many other species in the urban flora that prefer hot, dry microclimates. It is a striking specimen when it flowers—with two bright, clear blue petals on top and a smaller semi-translucent white petal which falls below the two "ears" of bright yellow and brown stamens protruding from the center. The dayflower, as its name suggests, expresses the most ephemeral of qualities in that each flower is only open for one day—although they are produced from summer until autumn. Its two- to three-foot-long succulent-like stems can root at nodes as they touch the ground, allowing it to move laterally from parent plants, but the stems quickly liquefy upon first frost. *Commelina* is also fast to generate from seed, especially with ample moisture. *Commelina communis* employs insect mimicry to entice prospective pollinators, attracting over twelve different species of bees, beetles, moths, and bugs. Current research suggests that asiatic dayflower may bio-accumulate metals such as zinc, lead, and cadmium, as the plant has been seen growing on copper mine spoils in China.

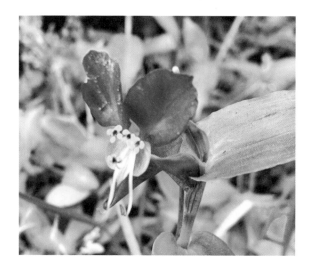

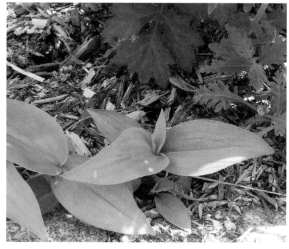

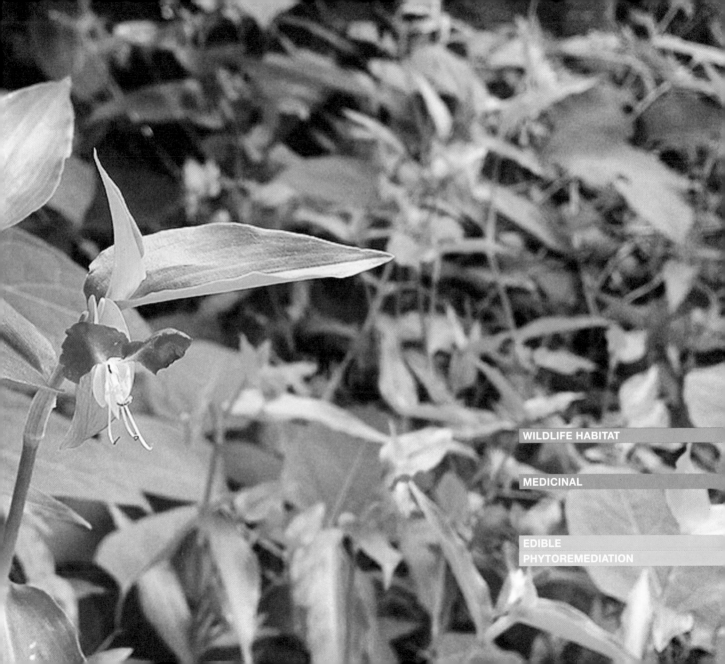

WILDLIFE HABITAT

MEDICINAL

EDIBLE
PHYTOREMEDIATION

RUMEX CRISPUS
Curly Dock

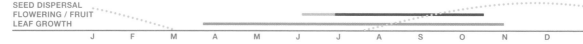

	J	F	M	A	M	J	J	A	S	O	N	D
SEED DISPERSAL												
FLOWERING / FRUIT												
LEAF GROWTH												

Rumex crispus is most notable for its rich reddish-brown seed heads that share a post-industrial aesthetic with the rusty steel remnants of its decaying urban surroundings. Curly dock is another Eurasian plant that has naturalized across North America, since first observations of it in New England in the late 17th century. Relatively nonselective about habitat, curly dock can be found in sunny areas that are prone to temporary flooding, as well as dry, gravelly sites, vacant lots, gardens, and road edges. The plant produces a large rosette of foot-long foliage, with curly margins and a prominent midrib. Flower stalks can reach a height of five feet, but are more often two to three feet tall. Dense whorls of apetalous green flowers appear along the stem in early spring, soon followed by tight clusters of seed. The prolific seed can remain viable for fifty years and is very distinctive in shape with each fat, oval seed being surrounded by a papery husk that enables a variety of distribution types. *Rumex crispus* can also reproduce when pieces of its stout taproot are detached, which allows the plant to thrive in disturbed sites. Curly dock has proven to be capable of accumulating heavy metals like cadmium and zinc from contaminated soils.

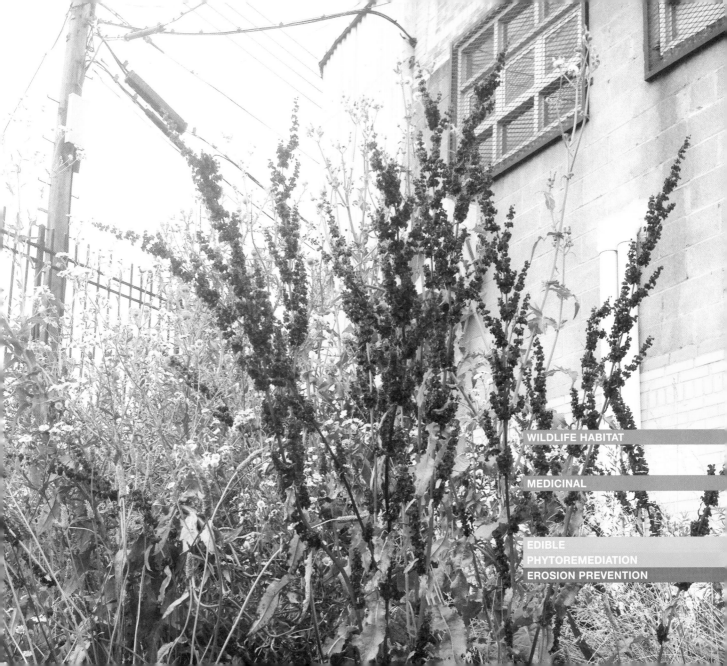

WILDLIFE HABITAT

MEDICINAL

EDIBLE
PHYTOREMEDIATION
EROSION PREVENTION

LACTUCA SERRIOLA
Prickly Lettuce

| J | F | M | A | M | J | J | A | S | O | N | D |

There are many wild lettuces, the easiest of which to identify is prickly lettuce for its conspicuously lobed leaves, sharp-toothed margins, and spines on leaf undersides. *Lactuca serriola* is an annual or biennial herb growing to five feet tall, with distinctive, milky sap. While native to Europe, it has been introduced worldwide including throughout North America. It has a single hollow upright green or white stem that commonly grows from a rosette of green leaves. The flower heads are grayish-yellow and seeds are equipped with a feathery pappus which facilitates wind dispersal. Nutrient-rich soil and full sun are ideal site conditions, but it is a prolific colonizer of disturbed habitats and often grows along sidewalks and roads, capitalizing on the increased heat and helping to slow the flow of rainwater and sediment entering storm drains. Prickly lettuce is also well known as an edible plant, the wild relative of our domestic lettuces. The young leaves are edible raw or cooked, but the whole plant becomes bitter as it gets older. It is used as an asparagus substitute and edible oil is obtained from the seed. It has also demonstrated phytoremediation properties by absorbing heavy metals and binding them to organic matter.

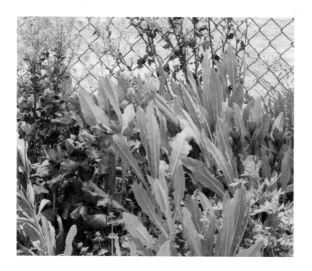

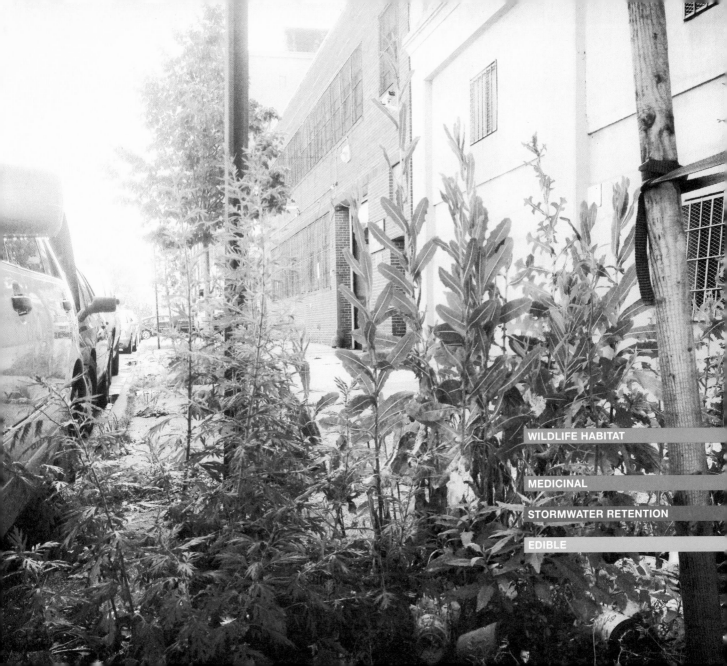

WILDLIFE HABITAT

MEDICINAL

STORMWATER RETENTION

EDIBLE

STATEN ISLAND, NYC
40°34' N, 74°8' W

EARLY SPRING WEEKDAY MORNING. IT'S ONE OF THE FIRST REALLY WARM DAYS OF THE YEAR. I DRIVE OUT
WITH A FUTURE GREEN STAFFER AND WE PICK A SPOT ON THE MAP. IT'S MORE SUBURBAN THAN WE PLANNED,
BUT THE WATERFRONT EDGE PROVIDES A LOT OF INTEREST. THERE ARE CONCRETE FOUNDATION VESTIGES OF
PRE-SANDY NEIGHBORHOODS WHICH ARE KIND OF EERIE. A NUMBER OF MORE TYPICALLY NONURBAN WEEDS
ARE SPOTTED.

WEATHER : WARM YET PARTLY CLOUDY
DURATION : 03:01:52

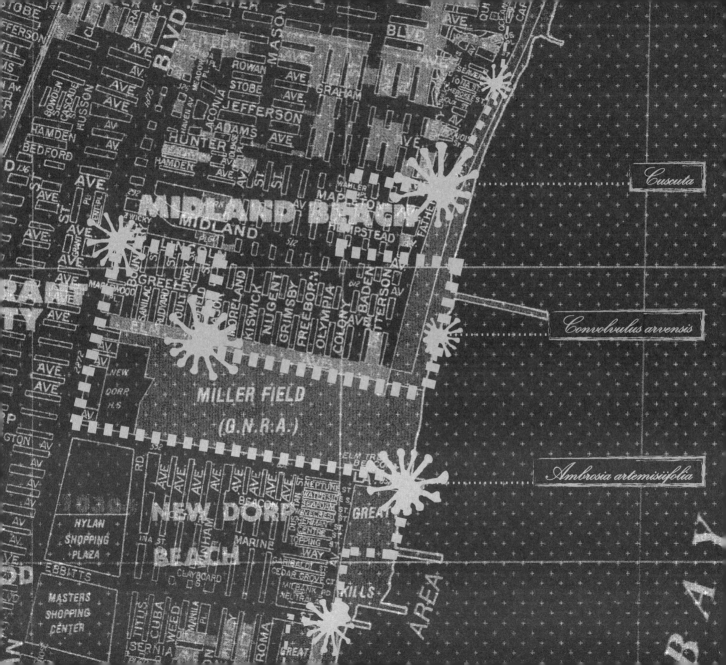

Cuscuta

Convolvulus arvensis

Ambrosia artemisiifolia

ECOLOGICAL DISSERVICE

noun / ˌiːkəˈlɒdʒɪkl , dɪsˈsɜr·vɪs/

NOT ALL WEEDS ARE GOOD NEIGHBORS. IN FACT, SOME WILD URBAN PLANTS ARE SO SUCCESSFUL ON DISTURBED SITES THAT THEY RAPIDLY INFILTRATE EXISTING FUNCTIONAL ECOSYSTEMS AND OUTCOMPETE THEIR NATIVE COUNTERPARTS. THESE ROGUE INVADERS ESTABLISH PERVASIVE MONOCULTURES—REDUCING FLORA AND FAUNA BIODIVERSITY AND RESULTING IN A DESTRUCTION OF NATIVE HABITAT. MOST SPONTANEOUS URBAN PLANTS PROVIDE A RANGE OF ECOLOGICAL SERVICES, HOWEVER THERE ARE SOME THAT SIMPLY OFFER NO BENEFIT TO HUMANS, WILDLIFE, OR THE ENVIRONMENT. THESE SPECIES ARE OFTEN TOXIC, PARASITIC, OR ARE SUCH AGGRESSIVE GROWERS THAT THEY CAN'T COEXIST WITH OTHER PLANTS AND DESERVE ERADICATION. THE DECISION ABOUT A PLANT'S INHERENT VALUE SHOULD BE SITE-SPECIFIC AND APPROPRIATE TO THE SURROUNDING CONTEXT. AS FURTHER RESEARCH IS COMPLETED, MORE METRICS SHOULD BE ATTRIBUTED TO THE POSITIVES AND NEGATIVE SERVICES EACH PLANT HAS TO OFFER.

ECOLOGICAL
DISSERVICE

CONVOLVULUS ARVENSIS
Field Bindweed

SEED DISPERSAL
FLOWERING
LEAF GROWTH

J F M A M J J A S O N D

Field bindweed forms a dense, tangled mat of vegetation that covers the ground, twines through other plants, and twists around the wires of chain-link fences. As a pioneer plant on disturbed sites, *Convolvulus arvensis* prefers sunny bare ground and heat to germinate, but it is adaptable on a range of sites, from fertile ground to compacted, lean soils. This perennial vine has deep, thick roots that can spread deep and grow horizontally through a lateral root system, making it a fierce competitor for limited resources. Any part of the rhizomatous root system separated from the parent can form a new plant, which frequently happens when the roots are disturbed or an attempt is made at "weeding." Its leaves bear an arrowhead appearance, with two pointed lobes. Flowers resemble morning glory, though they are much smaller and a pale pinkish white. Blooms appear for only one day, opening in the morning and fading by noon. The next step in their life cycle is to make seed, which they do with exuberance. Seeds are spread by water, birds, and animals. This plant offers seemingly no positive ecological services and it has been proven to be resistant to many herbicides and is equally difficult to eradicate by hand.

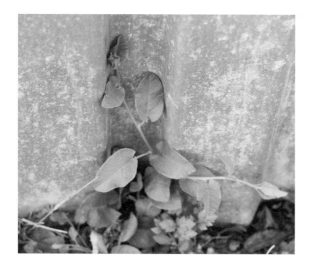

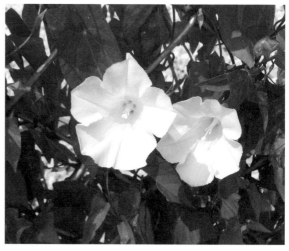

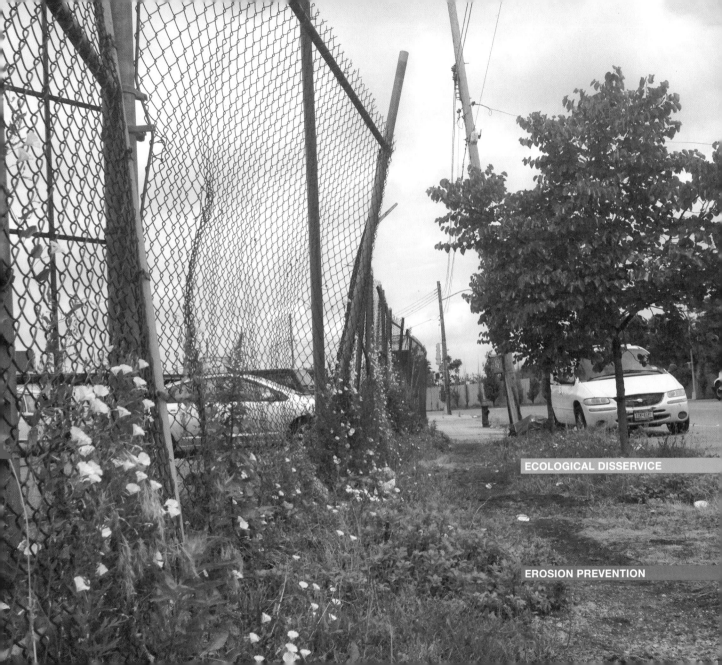

ECOLOGICAL DISSERVICE

EROSION PREVENTION

AMBROSIA ARTEMISIIFOLIA

Annual Ragweed

SEED DISPERSAL
FLOWERING
LEAF GROWTH

J F M A M J J A S O N D

Ambrosia artemisiifolia produces copious, wind-dispersed pollen in late summer, causing severe hay fever in those susceptible. Recent studies show a strong correlation between climate change and the extension of ragweed season with hotter, drier summers and delays in the first autumnal frost leading to a two- to four-week-longer period of pollen release. *Ambrosia* is as likely to be found in the rich soils of agricultural fields as it is growing in dry, urban soils, and places that receive regular applications of road salt. Ragweed germinates in the spring, favoring cooler temperatures than other common weeds, and can be

spotted quite early. Mature plants can grow to a height of three to five feet with a stiff branching habit. It is a strong competitor for natural resources and releases allelopathic compounds into the soil that further decrease the vigor of neighboring plants. While simply obnoxious to humans, *Ambrosia artemisiifolia* is an integral part of the wildlife food web in North America, constituting a significant part of the diet of birds, bees, caterpillars, and grasshoppers, and providing small mammals with winter forage. The competitive growth of the plant has been harnessed in phytoremediation efforts to remove lead from soil.

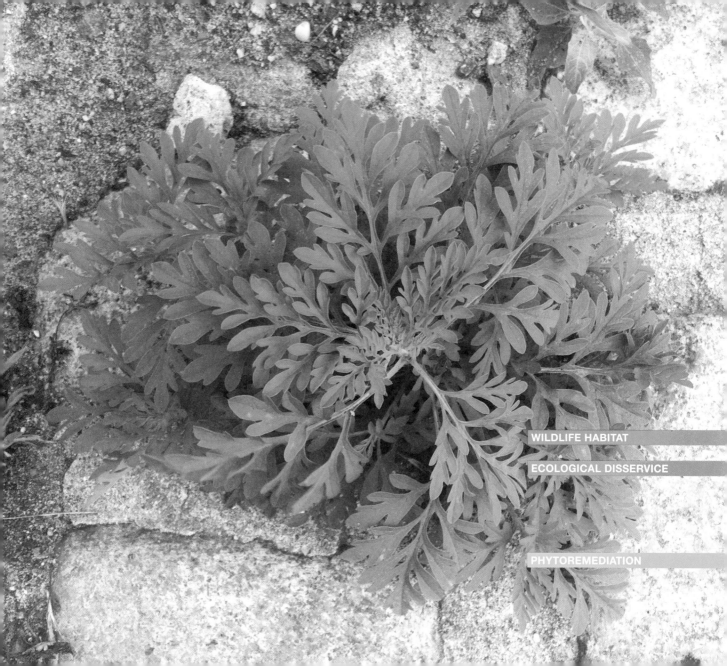

WILDLIFE HABITAT

ECOLOGICAL DISSERVICE

PHYTOREMEDIATION

CUSCUTA
Dodder

SEED DISPERSAL
FLOWERING
LEAF GROWTH

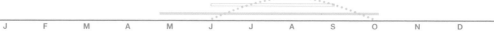

J F M A M J J A S O N D

Known by common names such as devil's guts, witch's hair, goldthread, and strangle-weed, *Cuscuta* is clearly spotted in the urban environment as a tangle of golden floss wrapped around other plants. A native nonparasitic plant, dodder possesses low levels of chlorophyll, which is the essential component of photosynthesis. It has adapted the ability to feed off other plants for their energy and inset itself into multiple hosts. After a dodder seed germinates, it only has a few days to find an appropriate host before it will die. Once embedded, *Cuscuta* absorbs essential nutrients from the plant's tissues. Dodder's leaves are reduced to minute scales that cling to the stems. Its tiny flowers can form dense clusters that, in turn, produce great quantities of seed, remaining viable for a decade. Some species of dodder are host-specific, but most will grow on a variety of plants, including grass, tomatoes, and clover. Dodder has seemingly no redeeming characteristics, except that the plant looks other-worldly and almost apocalyptic with its bright coloring and ability to overwhelm other plants. As a rootless, leafless plant, it's extremely difficult to control and doesn't respond to herbicides or manual attempts to eradicate it.

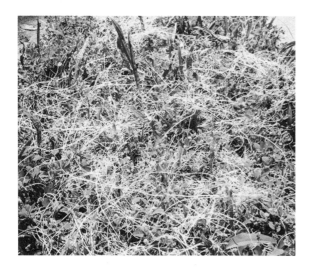

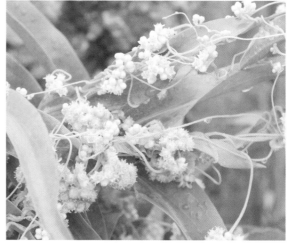

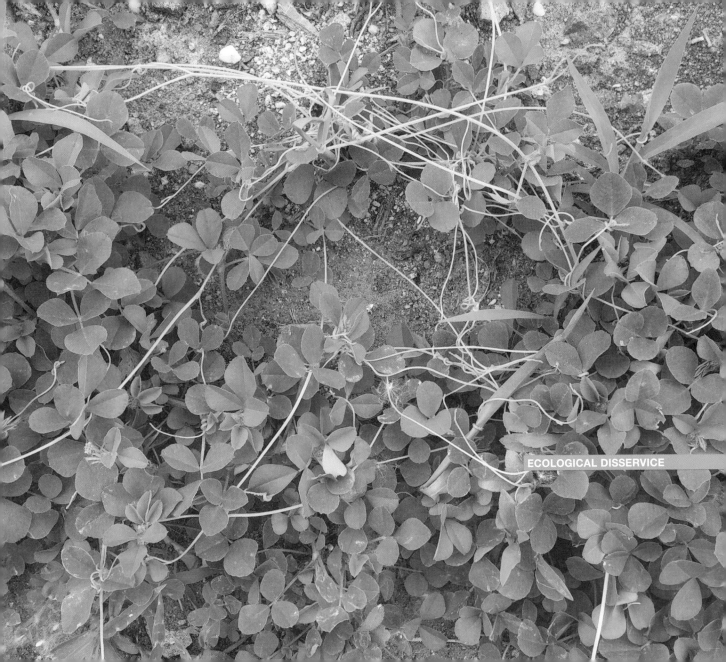

ECOLOGICAL DISSERVICE

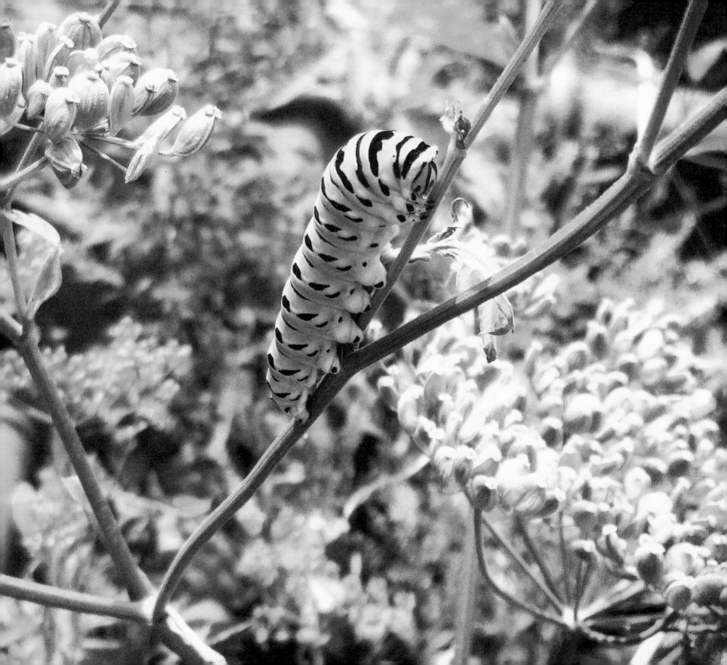

ACKNOWLEDGMENTS

The list of contributors to this book is long and spans many years, from 2009 to the present, and there are a few key players who've been the backbone of the project. Lois Farningham—the orchestrator of pure magic graphics—has been an integral part of the book's realization and helped to oversee the project administration while also providing literary support, graphic layout, and photo editing. Nancy Seaton—whose horticultural genius has been indispensable in helping to address plant identification through photographs and in developing the plant profile text with an insightful eye to the poetry each plant had to offer. Marcel Negret—the researcher extraordinaire whose explorations helped to situate the project in an historical context and whose detailed analysis aided in determining the plant matrix and the ecological services each plant had to offer.

Additional Future Green staff members played a significant role in the project's realizations over the years. Eri Yamagata, Lena Smart, and Khyati Saraf contributed to research and drafting of plant profiles for the book. Junbo Zhang, Minsang Kang, and Cecil Howell all participated in the summer of 2014 plant walks and photo documentation. In the 2013 D3 Natural Systems competition which focused on SUP, design staff included Zenobia Meckley, Koung Jin Cho, Sigal Ben Shmuel, Brett Kordenbrock, and Kate Rodgers. In 2011, our art project, "Profiles of Spontaneous Urban Plants," was led by Elodie Egonneau and Patra Jongjitirat, who conducted extensive plant research, photographed weeds for the plant profiles, and contributed to editing the essay. Doug Meehan was a key player in the realization of the website and should be commended for his web design skills. David Goldberg, Brian Sullivan, and Tyler Weeks deserve thanks for their patience and dedication to Future Green Studio.

This book could not have been possible without the oversight of the ARCHER team—Lisa Weinert, Heather Huzovic, Winona Leon, Julia Callahan, Alice Marsh-Elmer, and Tyson Cornell—whose wealth of experience and vision made this such an enjoyable process.

Special thanks to my gardener mother, who tended the weeds of my life while keeping me grounded and engaged with the social consciousness of the world. To my father, who was always supportive and gave me every opportunity to be successful. To my sister and her beautiful family, who are the people I call when a dose of unconditional love is needed. And to Robin and Mark, who played a key grandparent role in allowing me the time to develop this book, and whose support has been unwavering.

None of this would have been possible without the unflinching support of my wife Elyse, who has stood by my side through all the challenges and successes that have come to define the early years of Future Green Studio. She has supported my passions, elevated my confidences and tolerated all my weekends working and striving to create my own autonomous world. Without her, I would be a shadow of the man I am today. And lastly, to my beautiful and bright children—Lola and Aidan—who shimmer with the richness of life. Their spirits provide daily inspiration and serve as a constant reminder of what's truly important in the world.

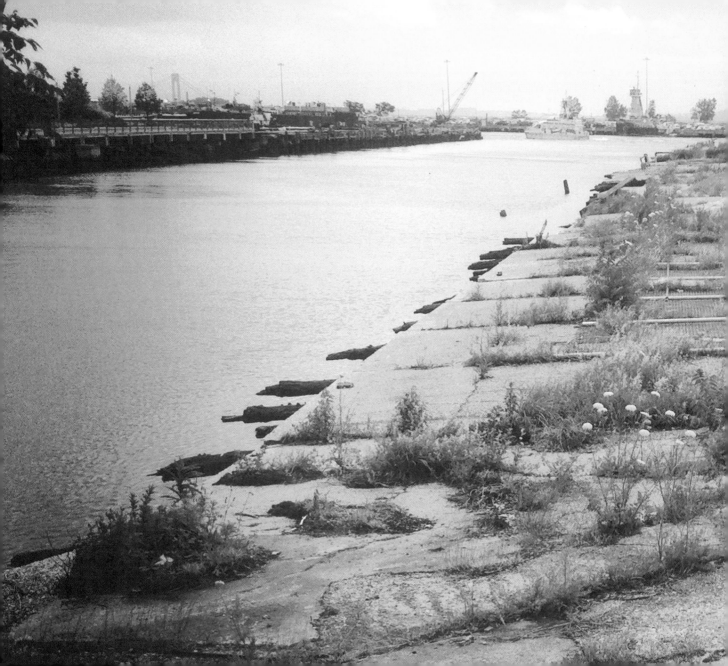

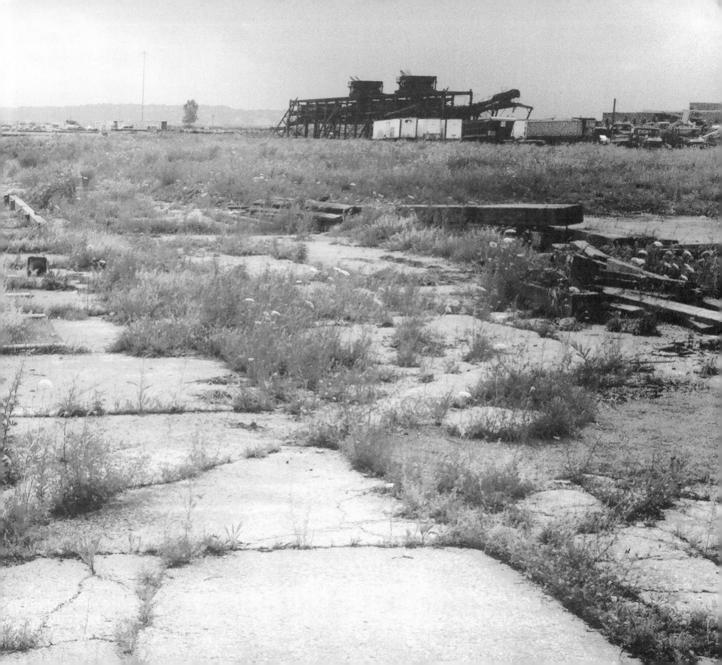

INDEX

Sources for Introduction:

i Peter Del Tredici, "Brave New Ecology," *Landscape Architecture 96(February)*: 46-52.

ii "Nuisance & Invasive Species," New York State Department of Environmental Conservation, last modified 2015, http://www.dec.ny.gov/animals/265.html.

iii Peter Del Tredici, "Introduction," *Wild Urban Plants of New England* (New York: Cornell, 2010), 6-7.

iv Anna Lenzer, "Monsanto's Roundup Is the Most Used Herbicide in NYC," *Mother Journal*, September 17, 2012, http://www.motherjones.com/environment/2012/09/monsantos-roundup-most-used-herbicide-nyc.

v Daniel Cressey, "Widely used herbcide linked to cancer," *Nature Publishing Group*, March 24, 2015. http://www.nature.com/news/widely-used-herbicide-linked-to-cancer-1.17181.

vi Dr. Pieter Tans, NOAA/ESRL (www.esrl.noaa.gov/gmd/ccgg/trends/) and Dr. Ralph Keeling, Scripps Institution of Oceanography (scrippsco2.ucsd.edu/).

vii University of Illinois at Urbana-Champaign, "Insects Take A Bigger Bite Out Of Plants In A Higher Carbon Dioxide World," *ScienceDaily*, 25 March 2008, http://www.sciencedaily.com/releases/2008/03/080324173612.htm.

Sources Exploring Rogue Territories:

i Arthur Schopenhauer, *Parerga und Paralipomena: Kleine Philosophische Schriften*, Vol. 2, Section: 76 (Berlin: A. W. Hayn, 1851), 93.

ii Francesco Careri, *Walkscapes* (Barcelona: Editorial Gustavo Gili, 2003), 26.

iii Geoffrey Alan Jellicoe, "Part One: From Prehistory to The End of The Seventeenth Century," *The Landscape of Man: Shaping the Environment from Prehistory to the Present Day* (London: Thames & Hudson, 1995), 11.

iv John Dixon Hunt, "Chapter 3: The Idea of a Garden and the Three Natures," *Greater Perfections: The Practice of Garden Theory* (Philadelphia: Univ. of Penn Press, 2000), 42.

v Pope Francis, "Encyclical Letter, Laudato Si of The Holy Father Francis On Care For Our Common Home," *Vatican: the Holy*, 24 May, 2015, Libreria Editrice Vaticana, 2005.

vi "Fourth Natures: Mediated Landscapes," conference at Waterloo, School of Architecture, Cambridge, ON, February 4-5, 2011.

vii "Working Group on The 'Anthropocene,'" Subcommission on Quaternary Stratigraphy, last updated May 5, 2015, http://quaternary.stratigraphy.org/workinggroups/anthropocene/.

viii "More than half of world's population now living in urban areas, UN survey finds," UN News Centre, July 10, 2014, http://www.un.org/apps/news/story.asp?NewsID=48240#.Vh1pE_lVhBe.

ix Witold Rybczynski, "The Cities We Want," The Slate Group, Novemeber 3, 2010, http://www.slate.com/articles/arts/architecture/2010/11/the_cities_we_want_2.2.html.

x "City portrait: Shanghai," World Cities Culture Forum, 2015, http://www.worldcitiescultureforum.com/cities/shanghai/.

xi Grahame Shane, "The Emergence of Landscape Urbanism," *The Landscape Urbanism Reader*, ed. Charles Waldheim (New York: Princeton Architectural Press, 2006), 57-58.

xii Vishaan Chakrabarti, "Building Hyperdensity and Civic Delight," *Places Journal*, June 2013, https://placesjournal.org/article/building-hyperdensity-and-civic-delight/.

xiii "Under the Elevated," Design Trust for Public Space, 2013, http://designtrust.org/projects/under-elevated/.

xiv The Trust for Public Land, *2015 City Park Facts*, Washington D.C., April 2015.

xv Witold Rybczynski, "The Cities We Want" (footnote ix).

xvi Francesco Careri, *Walkscapes* (Barcelona: Editorial Gustavo Gili, 2003), 26, quoted in Guy E. Debord, *Theory of the Dérive and other Situationist Writings on the City*, ed. Libero Andreotti and Xavier Costa (Museum d'Art Contemporani de Barcelona/Actar, Barcelona 1996).

xvii Ibid.

xviii Ibid.

xix Andrei Tarkovsky, "Chapter VII: The Artist's Responsibility," *Sculpting in Time: Tarkovsky The Great Russian Filmaker Discusses His Art*, trans. Kitty Hunter-Blair (Austin: University of Texas Press, 1989), 198.

xx Calvin Tomkins, "The Bride Stripped Bare," *Duchamp: A Biography* (New York: Henry Holt and Company, 1996), 12.

xxi Robert Smithson, interview with Maria Roth, "Robert Smithson on Duchamp," *Art Forum*, October 1973, in *Robert Smithson: the Collected Writings*, ed. Jack Flam (Berkely: University of California Press, 1996), 310.

xxii Ibid., 311.

xxiii Francesco Careri, *Walkscapes* (footnote i).

PARTICIPATE

How to participate?
We invite anyone with a smartphone to participate in creating a user-generated database of spontaneous urban plants, instantly accessible to everyone. Ensure your location data is turned on and, using Instagram, hashtag the photo with *#spontaneousurbanplants* to join in the fun.

spontaneousurbanplants.org